New Hope for Autism

*How Natural Peptide
Clathration Therapy Can Help
Your Autistic Child*

ISBN 978-1- 893910-53-9

First Printing, July 2008
Freedom Press
1801 Chart Trail
Topanga, CA 90290
Bulk Orders Available: (800) 959-9797
E-mail: books@freedompressonline.com

Contents

Introduction

This book is based on a series of investigative reports that were published in the national health magazine, *The Doctors' Prescription for Healthy Living*, whose mission is to highlight the best and most innovative products in natural health. We met Jim Cole a few years ago.

Cole is the founder and owner of Maxam Labs, a company which is gaining a reputation for helping autistic children to improve, and, in particular, is credited as a co-creator of the Peptide Clathrating Agent (PCA)-RX homeopathic formula that is helping so many needy children.

Cole has an advanced degree in electrical engineering, a field he excelled in for over 23 years. Because of the sudden, tragic passing of several close family members and friends, his life focus shifted on how to attain true optimum health. He was no stranger to healthy living, as his mother was well versed in alternative medicine, herbal remedies, wholistic health and was far ahead of her time in stressing the importance of whole foods and nutrition from an early age.

Cole has always been athletic, is an avid bodybuilder, and has a considerable background in the study of the body, quantum physics, spirituality, exercise, nutrition, biochemistry, holistic health, and sup-

plementation. For many years he has run his own gym in Hood River, Oregon, which has given him the opportunity to sponsor and work with many world-class athletes, including members of several Olympic teams.

Additionally, he had a health food store that inspired him to create another company called ASN (Advanced Sports Nutrition) when he found that lab tests revealed many available supplements were using inferior and watered-down ingredients. He developed his own products using only the highest grade and most potent ingredients. Further research included the study of Chinese and Ayurvedic medicine, and he incorporated this wealth of ancient knowledge into his products. He witnessed many people overcome health challenges by using his products and addressing their lifestyles holistically.

Still, he saw that even "healthy" people who ate all the right foods, exercised regularly, and did all the right things, sometimes still got cancer and other debilitating conditions. In fact, the overwhelming rise in degenerative disease in the face of this culture's rising awareness regarding healthy life choices and continuing research not only personally alarmed him, but it seemed as though no one was actually doing anything about it.

Cole then shifted his attention from looking for the cures of disease conditions to looking for the causes at the cellular level. He found that often the effects of various toxins (pollution, pesticides, food additives, etc.) become built up in the body and prevent the utilization and absorption of nutrients and the ability of the cells to properly communicate and that it was a crucial step to find ways to eliminate them.

It was then that he began working with a gifted, innovative chemist who was showing him the power of living organisms and cell signaling to naturally detoxify our cellular environment. They began a research facility in the Boston area and came up with the PCA-Rx formula. When parents of autistic children and people with Alzheimer's started sharing their amazing stories of healing, more

products were developed to aid in the regeneration of the body in addition to alleviating the toxic load.

"I wanted to help people, especially children. Sending healthy, conscious children into the future is our only future, and our only true resource. I began to see more and more autism cases in particular, and began learning about the link between autism, environmental toxins, and vaccinations containing mercury. Our children are our canaries in the mine, and with the current epidemic levels of autism spectrum, it should be of global species concern," Cole said.

How he came up with this formula and how it is helping children and others is the subject of this book.

At *The Doctors' Prescription for Healthy Living*, we have received so many letters, e-mails, and true-life interviews with people and their autistic children who've been helped by this formula and by this wonderful man's lifework that we thought it was important to tell you about it so that it may help more children in need.

1

Discovering a
Hidden 'Cure'

Aaron Corbett* of Troy, Michigan, was born in August 1995. He received his first routine vaccinations at 3 months. He cried three hours straight, then experienced what his parents described as a deep sleep with a high fever. "He did not awake until six or seven hours later," his father Brian said. "It was unusual. Up until then, we had never seen our son cry like that."

Aaron was given a second series of vaccinations in early 1996. "In retrospect," said his mother Joan Corbett, "perhaps we should have held off for a while, but waiting did not occur to us at the time."

"Although our son experienced a serious adverse reaction, we were not trained or educated in what to look for after the first vaccination," Aaron's father, Brian, said. "Elsewhere in the world, such as Japan or England, these adverse reactions would preclude any further vaccinations."

But, in retrospect, the changes manifested immediately. "Our son's stool turned a blue-green color," Brian said. "We inquired about his reactions and were told it was all very normal. The doctor gave us a pamphlet that said our child could have a reaction but not to worry because it is all very normal—the fever, rash, difficulty sleeping. They proceeded with the next round of vaccinations."

Slowly, changes consistent with autism became evident. It took about a year until they saw that his developmental progress had halted. At about age 2¹/₂, all-important eye contact between child and parent had decreased dramatically. Although Aaron could make many word sounds early on, his ability to verbalize also decreased.

When Aaron reached the age of 3¹/₂ , his parents enrolled him in a preschool for developmentally delayed children. "It was a nightmare," Brian recalled. "At such a tender age, he was put alone on a bus to go to school with people who were supposed to help. It was extremely stressful. When Aaron failed to reach some of the performance objectives set for him, the staff social worker told us he might be retarded."

"You know," he continued, "we were going through so much and then they start throwing this in."

Aaron also developed colic, constipation, and chronic diaper rash—another sign of vaccination-related gastrointestinal inflammation. "We ended up at the hospital emergency room once for severe constipation," Joan recalled.

Brian and Joan started reading, finding out everything they could about autism, including the link between vaccines, heavy metal exposure, and autism. "For both autism and heavy metal exposure," Brian said, "the symptoms are identical."

TOXIC METALS DISCOVERED IN AARON'S TISSUES

When Brian and Joan brought Aaron to a doctor for a hair analysis, the physician called personally with their results. "He said our son was loaded with heavy metals and that we had a serious problem."

Suddenly, they knew about the harm from vaccinations—how else could he have been exposed to mercury and other heavy metals? "But what do you do?" Brian asked. "How do you cure a child with heavy metal toxicity and/or vaccination-related autism?"

Aaron was prescribed oral chelation therapy, dimercaptosuccinic acid (DMSA), and alpha-lipoic acid. He also took injections of dimercaptopropane sulfonate (DMPS). Laboratory analyses demonstrated that he was slowly excreting mercury, lead, aluminum, cadmium, arsenic, tin, and thallium.

Aaron began to improve but not without a cost. DMSA chelation therapy was taxing to his tiny body. He developed black circles under his eyes and exhibited signs of fatigue. After a year of treatments, the doctor told Brian and Joan to give him a break.

By chance, the laboratory performing their son's heavy metal urinalysis tests had enclosed a flyer about PCA-Rx.

This is the formula we discovered at *The Doctors' Prescription for Healthy Living* that was helping so many people, children and adults alike. It's bio-fermented, contains metabolic clathrating peptides, and is part of the rebirth of the popularity and healthy benefits of probiotic nutrients.

This product is specifically from Maxam Labs, a little-known Hood River, Oregon, nutrition company. In the case of the Corbett family, Maxam provided their test results demonstrating that PCA-Rx was producing, in some cases, dramatic detoxification results. So, after discussing it with their doctor, Brian and Joan decided to give PCA-Rx a try. Because it removes toxins differently, it would provide the needed break from the DMSA regimen and help Aaron to continue to eliminate his heavy metal burden.

AARON STARTS ON PCA-RX

Brian and Joan contacted James Cole about Aaron. After interviewing the Corbetts, we went to Cole to get his side of the story.

"Aaron had not been animated for almost 4 years. He was inside of a shell. I told them that they would have to work with their doctor, but that we have had a number of successes with autistic children— where the children have come all the way back to being full-fledged

normal, healthy kids. I recommended they take Aaron off most of the supplements they had him on—except for their ionic mineral formula, since heavy metal toxicity robs the body of nutritional minerals. His poor little liver and body were trying to process so much stuff. I wanted to get him on a clean diet. I wanted him away from exposure to toxic chemicals. I told them that there was absolutely no toxicity associated with PCA-Rx."

"The recommended dosage of PCA-Rx is one spray bottle per month," Brian said. "After discussing it with our doctor and Jim, we decided to increase our son's dosage to *two bottles a week*. While we were doing this, we were still doing urine samples and getting them tested. But with only the PCA-Rx at the new higher dosage and our ionic mineral supplements, his heavy metal output increased by two to three times. Also, DMSA can only be administered cyclically. But with PCA-Rx, we could go 7 days a week. In 2 months, we had the same benefits with PCA-Rx as using DMSA for an entire year. Also, unlike DMSA, PCA-Rx will not chelate beneficial minerals, one reason it is less stressful to the body."

MARKED IMPROVEMENT

Aaron's progress was noteworthy. "The improvements must be considered 'soft science'—the kinds of changes a mother notices first," Brian said.

"But what a change!" Joan said. "He was verbalizing a lot more. His eye gaze improved. That's what you notice with all of these little kids. They do not focus on anything for very long. There was greater language comprehension. When we asked him to do something, we no longer needed to gesture or point. The doctor noticed this too. He was impressed."

Aaron experienced improved temperament, and his coordination improved. Kids with autism and/or heavy metal poisoning also experience muscle and stomach pains and headaches. All of this has gone

away. Best of all, Aaron experienced absolutely improved sleep patterns. A child with heavy metal poisoning/ autism usually experiences erratic sleeping habits. They may be up at 3 or 4 in the morning, running around the house, which leaves the parents chronically exhausted. Since detoxing, "Aaron began sleeping through the night. His gross motor skills improved. All of a sudden he could open Ziploc bags. He could open jars. He can untie knots now, even multiple knots. Before, he could not untie even the simplest knot."

"His social skills are improving, and he is demanding interaction with us," Joan said. "He no longer wants to be alone. He insists when watching a video that we come and sit with him."

"We are going back to the way he interacted when he was 1 or 2 years old, so we have a lot of catching up to do. But it's wonderful. He is breaking through. We still have a long way to go, but we are hopeful. PCA-Rx is helping to eliminate these symptoms. The PCA-Rx with ionic minerals has outperformed everything else up to this point."

WHAT IS AUTISM?

Not until the middle of the twentieth century was there a name for a disorder that now appears to affect an estimated 1 in 166 children, a disorder that causes disruption in families and unfulfilled lives for many children. In 1943 Dr. Leo Kanner of the Johns Hopkins Hospital studied a group of 11 children and introduced the label *early infantile autism* into the English language. At the same time a German scientist, Dr. Hans Asperger, described a milder form of the disorder that became known as Asperger's Syndrome.

Autism is the most severe of a range of neurological conditions called autism spectrum disorders. It limits the ability to communicate, form relationships, and respond appropriately to the environment. Symptoms can include loss of language and eye contact, extreme withdrawal, violent or repetitive behavior, and extreme sensitivity to light and sound.

It's been suggested that broader definitions and better reporting are behind the apparent spike. But a study in 2002 by the MIND Institute at University of California–Davis found that these are at most minor factors and that the increase is real.

"As the newly developing cells and neurons are exposed to the high toxic load of heavy metals and environmental poisons, autism becomes a natural response to creation under toxic stress. This exposure could actually occur *in utero*, or as a predisposed genetic condition from grandparents to parents to child. Long-term exposure could be identified as dementia, Alzheimer's, or hundreds of other toxin-related conditions," according to Cole's research.

Parents are usually the first to notice unusual behaviors in their children. In some cases, the baby seemed "different" from birth, unresponsive to people, or focusing intently on one item for long periods of time. The first signs can also appear in children who seem to have been developing normally. When an engaging, babbling toddler suddenly becomes silent, withdrawn, self-abusive, or indifferent to social overtures, something is wrong. Research has shown that parents are usually correct about noticing developmental problems, although they may not realize the specific nature or degree of the problem.

2

The Mercury Link

Ten years ago, autism was estimated to affect 1 in 10,000 children. According to the National Institutes of Health, it is now anticipated to affect 1 in 166 children. There are families with multiple children who are autistic. Jim Cole had talked to several parents that had three and four children with autism in the same family. There is a family with an educational website online that has six children with autism and Asperger's syndrome.

A story first reported in the August 7, 2004, *Los Angeles Times* sheds light: As parents of two severely autistic boys, Kevin and Cheryl Dass of Kansas City, Missouri, faced a world of heartache and worry. "It's torn our life apart, it really has," Kevin Dass told the paper. "And it didn't have to happen. The boys were born prematurely and alarmingly small. Yet at 3½ months, they were given four shots in a single day, including three containing small amounts of mercury, a neurotoxin.

"They were still in the hospital on oxygen, staying alive, and they put this poison in them," Dass says. "They were fried. They were totally fried."

Like many anguished parents of autistic kids, the Dasses blame the condition on thimerosal, a mercury-based preservative that until recently was added to many routine children's shots.

"Thimerosal-containing vaccines are now given with abandon," says Amy Holmes, M.D., in an online article at www.healing-arts.org. "Upon its arrival into our world, the newborn is greeted with a Hepatitis B vaccine. He then receives several more doses of this vaccine along with DPT and Hib vaccines. All three of these vaccines contain relatively large amounts of thimerosal, which is 49.6% ethylmercury by weight. It was not long ago that the only vaccine containing thimerosal was the DPT vaccine. But, the Hepatitis B vaccine was made 'mandatory' in 1991 and the Hib vaccine a few years earlier. Is it a coincidence that the incidence rate of autism has soared in the 1990s? Is it better diagnosis or is it more mercury early in life? Add onto these noted exposures the thimerosal-containing RhoGAM injection. A reasonable conclusion of greatly increased mercury exposure to developing fetuses, newborns, and young infants being responsible for the obvious autism 'epidemic' is almost inescapable."

Although not all researchers believe that environmental toxins or proliferating numbers of childhood vaccinations play a role in autism and other neurological disorders, it would be hard to argue against the clinical observations of Dr. Jeffrey Bradstreet, M.D., who has treated and investigated more than 1,000 children with autism spectrum disorders. "To be sure, there is no one cause of autism, but the link between vaccinations with high amounts of mercury and potentially toxic measles antibodies, as well as other toxic environmental exposures, is not to be readily dismissed," he says.

"The vast majority of these children suffer with autoimmune and toxicological disorders, which disrupt normal immune, gastrointestinal, and neurological functions," Dr. Bradstreet said in expert testimony April 25, 2001, before the U.S. House of Representatives, Committee on Government Reform. "Vaccine constituents are at least theoretically capable of inducing these changes. Mercury, aluminum, measles attenuated vaccine strain, pertussis toxoid, Hib and Hepatitis B seem to head the list of [vaccination-related] trouble-

makers. But vaccines are only one potential source for the rising tide of neurodevelopmentally abnormal children. Chronic exposure to environmental toxicants, particularly for the unborn, has been identified by the Environmental Protection Agency (EPA) and the World Health Organization (WHO) as a serious issue. The list includes PCBs, pesticides, complex petrochemicals, off-gases from plastics and carpets, and thus the list seems to be unending for the potential problems we are creating for our children."

Already, we know that risk for adult-onset Parkinson's, ADHD, and violent or antisocial behavior among children and adults alike is clearly linked with accumulating levels of environmental pollutants, such as pesticides, manganese, and lead. Is the link to autism soon or one day to come?

3

Heavy Metal Detox and Beneficial Bacteria

Mention bacteria and people are likely to conjure up images of unpleasant, disease-causing microorganisms, writes Masami Fujiwara. "Yet bacteria do more than cause food poisoning and skin infections. Most are harmless to humans, and some are even necessary for our survival. Without thinking about it, we rely on one of their major characteristics: the capability to break things down. Bacteria degrade the garbage we dump every day, they degrade the leaves that plants drop before winter, and they degrade animal feces. If it were not for the action of bacteria, those substances would remain in their original condition forever, and their contents would not be available for recycling and reuse by other living things. Researchers at various institutions, including the University of Alaska–Fairbanks, have paid attention to this characteristic of bacteria and have started research on the creatures to see if they can be used to clean up our environment." Cleaning up wastes in the environment by using bacteria is called *bioremediation*. Researchers are working on bioremediation of crude oil, cyanide, PCBs, methyl mercury, and various other hazardous industrial wastes in the environment.

"Bioremediation has been applied in Alaska, most conspicuously to help clean up oil spilled from the Exxon Valdez in 1989. By releasing

specific fertilizers in Prince William Sound, researchers were able to enhance the growth of indigenous bacteria that can degrade crude oil.

"This effort was discussed (among other places) in an article by J. E. Lindstrom and colleagues that appeared in a 1991 issue of the journal *Applied Environmental Microbiology*. The researchers believe the results demonstrated the feasibility of bioremediation to clean up oil released in the environment.

"Another substance that researchers are trying to clean up with bacteria is PCBs, a family of common industrial chemicals. Now banned, PCBs do not degrade easily, so significant amounts of the compound still exist in the environment. Sometimes it's in truly dangerous places: the contamination of dairy products with PCBs is a national concern. Since natural bacteria aren't very effective at degrading this compound, researchers are looking into genetically engineering bacteria for the job. They will extract genes from bacteria with any ability to degrade PCBs, study the genetic information to ascertain which genes produce the required ability, then amplify the desired genes and reinsert them in the bacteria in the hopes of making supermicrobes capable of truly breaking down PCBs.

"Researchers are also working on bioremediation of cyanide, a toxic compound but one important in an effective method for extracting gold from its ore. Though studies of using bioremediation to clean up cyanide are still in an early stage, the importance of gold mining in Alaska makes this a technology that bears watching."

Yet, this same principle that intrigues industrial scientists also intrigued other scientists.

PIECING TOGETHER THE PUZZLE OF AUTISM
Great Smokies Diagnostic Laboratory has been pioneering many different diagnostic tests that allow us to determine whether the gut flora of autistic children are in balance, and whether their intestinal tract suffers from excess permeability. Could there be a link between

an imbalance of gut flora, intestinal permeability, and autism? (By permeability, we mean that the gut leaks and is allowing undigested chemicals to pass directly through into the bloodstream. Some of these compounds are thought to be toxic and manifest their toxicity as autism symptoms.)

Childhood vaccinations have been implicated in the onset of autism, while diet has been implicated in its subsequent prognosis, Dr. Brudnak points out. A strong gut-brain connection is also apparent, with poor digestive function often appearing as a hallmark of the disorder. That takes us back to Normie, the 7-year-old son of Dr. Campbell-McBride, M.D., whose initial symptoms were accompanied by severe gastrointestinal distress.

According to the *Great Smokies Connection* newsletter [October 10, 2001; 14(5)], "Dr. Brudnak speculates on the following chain of events. In early childhood, sensitivity to a vaccine, or a reaction to a mycobacterial infection, could disrupt pivotal molecular mechanisms that regulate how specific genes in the body switch 'on' or 'off'— what's known as genetic expression. This may trigger malfunctioning of the immune and gastrointestinal systems, particularly in gut-associated lymphoid tissue, which Dr. Brudnak cites as 'a major contributor to the pathological manifestations of autism.'"

"When this happens, proteins are no longer properly broken down in the digestive tract. Cells in gut tissue die off prematurely, as the gut lining becomes 'leaky' and unable to repair itself. Compounds in the diet, like casein and gluten, normally kept at bay, may then permeate into the bloodstream. Their activated by-products, called exorphins, could act directly on the brain to trigger opioid-like effects associated with autistic symptoms.

"Such a scenario could explain why restoring healthy gut barrier function in autistic children is a treatment approach that 'has met with a degree of success,'" Dr. Brudnak observes. "Enzyme therapy (which improves the gut's ability to break down proteins) and probiotics

(supplementation with beneficial gut microbes that help repair the intestinal lining) have both produced positive clinical results in autistic children," he points out.

"In most cases symptoms of autism begin in early infancy. However, a subset of children appears to develop normally until a clear deterioration is observed. Many parents of children with 'regressive'-onset autism have noted their children were given antibiotics immediately prior to the regression and that such use was followed by chronic diarrhea. This leads researchers to speculate that in a subgroup of children, 'disruption of indigenous gut flora might promote colonization by one or more neurotoxin-producing bacteria, contributing, at least in part, to their autistic symptomatology.'"

This line of thought stimulated recent research at the Section of Pediatric Gastroenterology and Nutrition, Rush Children's Hospital, Rush Medical College, Chicago. To help test this hypothesis, researchers took 11 children with regressive-onset autism for an intervention trial using a minimally absorbed oral antibiotic. Short-term improvement was noted using multiple pre- and post-therapy evaluations. "These results indicate that a possible gut flora–brain connection warrants further investigation" as a "meaningful prevention or treatment in a subset of children with autism."

Now let's take this even further and look at what happens to the gastrointestinal health of children with chronic gastroneurological-related disorders.

"The challenge that many chronic disorders pose to modern medicine is that they often emerge as an interrelated tapestry of imbalances within the human body, rather than in response to a single, isolated cause," notes the newsletter. "And autism may be a prime example of this."

Many children with autism have chronic digestive problems. In fact, gastrointestinal symptoms in autistic children often first appear in conjunction with initial changes in emotion and behavior during

the onset of autism, leading researchers to suspect a gut-brain connection.

A recent study in the *American Journal of Gastroenterology* lends strong support to this possible gut-brain link.[2] Researchers performed a colonoscopy on 60 children with autistic spectrum disorders who also had symptoms such as stomach pain, constipation, bloating, and diarrhea. The autistic children had much greater evidence of intestinal lesions than healthy children or non-autistic children with similar digestive problems.

More than 90% of autistic children showed clinical evidence of chronic enterocolitis, such as lymphoid nodular hyperplasia, a sixfold greater rate than found in the non-autistic children with inflammatory bowel disease.

"The pathology seems to reflect a subtle new variant of inflammatory bowel disease..." the researchers concluded, "a type of 'autistic enterocolitis.'"

Enterocolitis is an inflammation of the mucous membrane of the intestine. Researchers are not sure what could be causing the condition in children with autism, although it usually arises from chronic immune reactivity.

In autism, such immune responses might be triggered by substances in the diet (e.g., opioid peptides), viral agents (such as the measles virus), mercury, or other causes, the researchers speculated.

The opioid peptide theory was first presented to the medical world in 1979.[3] Excess peptides (breakdown products of dietary proteins) act as opioids affecting neurotransmitters within the central nervous system.

In the normal course of events, proteins are digested in stages by enzymes; firstly to peptides (the intermediate compounds), then to smaller amino acid components, which are absorbed into blood capillaries in the gut mucosa. The larger peptides are generally unable to cross this membrane barrier, but when they do, they can act as opioids

affecting neurotransmitters in the brain, causing abnormal behaviors and/or activity. This theory suggests a higher percentage of these opioid peptides reach the brain in autistic children.

These incompletely digested peptides—known as exorphins, casomorphins, and gluteomorphins—usually come from milk proteins such as casein or from wheat (gluten) and are structurally similar to morphine. In experimental studies, they have been shown to exert a morphine-like neurological influence. The formation of excess peptides in the gut is possibly associated with sub-optimal enzyme activity or an insufficient supply of enzymes required to break down these peptides. This may be genetic in origin, or caused by other factors, such as enzyme inactivity secondary to nutritional deficiency, or by altered gut microflora.[4,5] So if we repair the imbalance of beneficial bacterial organisms in the gut and the gut lining, which we can with soil organisms, we have a chance to help some of our children with autism.

Indeed, a report from a dietician at the Royal Free Hospital, London, published in the *Journal of Family Health Care* recently discussed the link between autism and abnormal gut flora "and the use of probiotics and prebiotics in improving the integrity of the gut mucosa."[6]

"The gut-brain connection is now recognized as a basic tenet of physiology and medicine," writes Eammonn M. M. Quigley, M.D., in a related editorial, "and examples of gastrointestinal involvement in a variety of neurological diseases are extensive."[7]

Andrew Wakefield and colleagues have raised the possibility that a subset of children with pervasive developmental disorder (which includes autism), particularly those with a history of developmental regression and chronic gastrointestinal symptoms, have a dysregulated immune response to the measles antigen from the measles-mumps-rubella (MMR) vaccine. This has been suggested as a possible precipitating factor associated with intestinal abnormalities.

Besides aiding repair of the gut lining and improving digestion, there is both anecdotal and clinical evidence that "human-based organisms" such as that are part of the creation of PCA-Rx can help with detoxification, notes a recent report from *Clinical Pearls*, one of the nation's premiere nutrition newsletters. "Aerobic organisms have been shown to readily detoxify mercury.... According to the American Academy of Pediatrics, 90% of methyl mercury is excreted through bile in the feces.... With large numbers of probiotic bacteria, mercury can effectively be driven toward expulsion. The administration of probiotics would prevent any recycling of toxic mercury. Mercury can cause an autoimmune response."

4

A Natural
Detoxification Supplement

If your child's autism is accompanied by gastrointestinal distress,
the potential for PCA-Rx to help might be further amplified.

WHAT IS PCA-Rx?

Jim Cole explains, "Before we can identify what PCA-Rx is, we must first understand, to a certain level, what a human is, how life functions and evolves, and the adaptation process of the cell and mitochondria."

"We, as humans, are the collective intelligence of over 100 trillion cells—life. About 50% of these cells are us, with our very own identity known as DNA. The other 50%, or about 50 trillion cells, belong to bacteria and microbes, etc., that work for us. This would include our immune system, food digestive process, wound healing, enzymes, both digestive and metabolic, and more. We are basically a walking, talking ecosystem, within an ecosystem, within an ecosystem."

"The creation of life within us begins at the microbial level, and together with our DNA, stem cells, electrons, protons, and neutrons, life is being created every microsecond of every day of our lives. New cells are being born, and old cells are dying and being removed from our self-contained ecosystem. Every time a new cell is to be born— and this process goes on billions of times each day—our system wants to create the most perfect cell for the prevailing perceptual conditions."

"Our brain and sensory system have been monitoring and recording billions of bits of information every second for this very purpose. Microbes and bacteria can adapt, regenerate, and create immune function bioregulators in several days, ultimately to help create a higher-functioning, healthier host, which is us. This is called genetic expression and cell signaling. The complete human reproductive process takes about 20 years, but the microbes can up-regulate our adaptive functionality in a matter of days."

"Humans, with our never-ending fascination of control, dominance over nature, and the creation of chemicals and toxins, have thrown the human genome into a bit of a tailspin. Chemicals, drugs, poisons, food processing, and antibiotics were never a part of the ultimate plan of creation or life on planet Earth. We are poisoning ourselves at a rate that is faster than nature can adapt. We are ultimately on the extinction pathway."

"In the formulation of PCA-Rx, we start off with microbes that are, and have been, a part of the human makeup and immune function for millennia. Over time, we expose them to all of the toxins, poisons, pesticides, heavy metals, and chemicals that are present in our environment. In the interest of their own survival, the stronger and more adaptive microbes remove the toxins. This microbial housekeeping helps humans adapt and survive in their given environment."

"We then isolate out bioregulators and genetic expression modifiers related to, in this case, the detoxification process. This forms the basis for PCA-Rx.

"As the affected individual then takes the products, we believe, their own microbial ecosystem and immune function is improved. PCA-Rx is not actually treating any particular condition but instead is assisting the body in its reduction of toxins."

"In the beginning, we thought of PCA-Rx as simply a better method to remove heavy metals," noted Cole in an interview with *The Doctors' Prescription for Healthy Living*. "But what our anecdotal

research found was that any disease condition linked to a toxic over-load also exhibited marked improvements and was actually getting better." Some PCA-Rx users on dialysis have reported that they no longer required their treatments. Two cases in particular, a lawyer on dialysis, and another patient, an engineer, both of whom were work-ing with doctors, claimed that once they were able to remove the tox-ins, especially heavy metals, their kidneys were able to function well enough that they no longer required dialysis. In fact, the lawyer was on a list for a kidney transplant.

Heart patients have reported improvements, too. However, despite these dramatic anecdotes, understand that the formula isn't a drug and cannot replace any drug. It is a means of healthy support. "We realize now we have a universal product with many facets, and that the primary cause of many disease conditions is the accumulation of toxins and heavy metals in the body over time."

"Keep in mind, despite this enthusiasm, it is not a cure," says Cole. "It does not treat a disease. We believe it is a natural immune-enhancement pathway, so it can only support good health."

Many consumers have heard or read about chelation therapy, which may be administered orally or intravenously. Chelation ther-apy is widely recognized as an important method of removing heavy metals from body tissues and utilizes various agents such as DMSA, sodium DMPS, or ethylenediaminetetraacetic acid (EDTA) to bind metal ions and sequester them from body tissues."

"But while conventional oral chelation therapy may be described as one dimensional, heavy metal detoxification with PCA-Rx is a three-dimensional process that works on the principle of clathration," said Cole. "Its contingent of specifically sequenced glycoproteins and pep-tides form a lattice or inclusion complex. Multiple receptor sites attach to a toxic molecule, literally wrapping around the toxic sub-stance to prevent additional reactions with tissues or organs as it is eliminated from the body."

"Unlike the ionic bond utilized to transport metals from the body with chelation, clathration with PCA-Rx utilizes ionic, covalent, and hydrogen bonds. Not one but three major types of bonds at multiple points are created."

This represents a true breakthrough in the field of oral-chelating agents.

Here are some more key points about the formula.

Nutrient particles measured in nanometers: "We usually think of the amounts included of particular nutritional supplements in terms of milligrams and micrograms. But PCA-Rx nutrient particles are formulated in the range of nanometers—reduced to their bare peptide essential configuration—and placed in a natural colloid. The body recognizes this peptide as a nutrient."

Enhanced oral absorption: "Absorption is made more efficient since these colloidal nanometer particles also provide the water carrier with the hydrogen bond angles increased to 180° F (linear water), thus lowering the surface tension and making the water "wetter," thereby enhancing absorption through the oral mucosa."

Affinity for cell membranes: "Each nutrient particle carries a quadraionic surface charge, and cells contain a reciprocating quadraionic surface charge, so absorption occurs electrokinetically, which is a much more efficient method of absorption than osmosis where 50% maximum levels may be achieved at best. Because of the particle size and bare, stripped-down nature of the peptides, the PCA nutrients gain access into the mitochondria of the cell where they get to the heart of their housecleaning project. There, a peptide ligand complex binds with greater affinity to cell receptor sites than heavy metals, thereby releasing the heavy metals. The companion molecules then clathrate (wrap around and enclose) the toxic substance, keeping it enclosed as it enters the body's elimination pathways. The bond is a strong one, too. PCA-Rx's nutrients bond to toxic chemicals with ionic, covalent, and hydrogen bonds

as compared to sodium dimercaptopropane sulfonate (DMPS, the most commonly used, controversial chelation agent), which utilizes only a single ionic bond."

Does not remove beneficial minerals: "PCA-Rx will not bind to beneficial minerals because those that belong in the body are tightly bound and protected by their natural enzymes. Heavy metals and toxins do not have enzyme systems to protect them. PCA-Rx targets non-complexed, loosely bound metals. It is believed, based on people's experiences, that if there is an excess of a natural mineral in the body, as with calcium-based plaques, PCA-Rx will also bind these and remove them. We believe that metals are clathrated in the following prioritized order due to their descending valences: lead, thallium, cadmium, arsenic, aluminum, and mercury. This is important to note because if your system is saturated with lead or another heavy metal, your urine mercury readings will not likely drop until you have clathrated the metals with higher valences. In addition, mercury goes into a methyl form and can be stored in fatty tissues, making removal more challenging."

Says Cole, "PCA-Rx is a powerful detoxifying dietary supplement that effectively removes heavy metals, toxins, and other harmful contaminants from the body. PCA-Rx contains immune system-enhancing peptide fractions developed by many beneficial microorganisms and bacteria produced through a proprietary cell fermentation process. Based on numerous reports of over 10 years of use, users of PCA-Rx have reported that it can safely and effectively cleanse the systems of people who suffer from the effects of heavy metal toxicity as well as the long-term buildup of vaccination residues, vascular plaque, chemicals, polychlorinated biphenyls (PCBs), mycoplasmas, prescription drug leftovers, pesticide components, infectious proteins, and other bodily pollutants. And as it does so, it removes no beneficial minerals from the body's system. Anyone living in areas and/or working in industries

where lead, mercury, and other toxic metal exposures exist may find PCA-Rx beneficial, as might persons with mercury amalgam dental fillings and those whose bodies have otherwise reached toxic saturation."

Quick Definition

Clathrate: Relating to or being a compound formed by the inclusion of molecules of one kind in cavities of the crystal lattice of another.

CLINICAL REPORTS
FOR HEAVY METAL REMOVAL

Clinical reports shown below tell us that PCA-Rx is a powerful dietary supplement for detoxification. Anyone working in industries with exposures to cadmium, lead, mercury, and other toxic metals may therefore find PCA-Rx to be a powerful health ally. Persons with mercury amalgam dental fillings may also find PCA-Rx beneficial. In the future, we will report on its uses in many other potential areas of toxic bio-accumulation. For now, let's examine several clinical case reports involving mercury contamination from both occupational and dental exposures.

Mercury Poisoning Case #1

A November 30, 2000, case study bulletin reported on a 57-year-old male who had had his dental amalgams removed but was suspected of having toxic levels of heavy metals due to a DMPS urine challenge. This patient also was employed in a profession wherein he was potentially exposed to mercury and copper on a regular basis. According to his doctor, he showed "very elevated" levels of mercury at 21 micrograms per 24-hour period with a normal reference range of up to only 5 mcg. On this test, no other toxic elements were beyond the reference range (urinary testing by

Doctor's Data and stool analysis by Great Smokies Diagnostic Laboratory).

The patient was begun on PCA-Rx for approximately nine days. Post-provocation results showed PCA-Rx pulled toxic metals from the body through both the renal (kidney) and bowel systems without patient complaints. In fact, according to testing, PCA-Rx eliminated some 300% more arsenic than the pre-test. Stool analysis showed that mercury excretion increased 2,650% from .009 milligrams per kilogram (mg/kg) to .239 mg/kg. Since urinary mercury excretion was lower on the post-challenge test and stool mercury excretion increased so dramatically, it is clear that the bulk of bound metal was removed through the bowels. Other toxic metals that increased in the stool were arsenic, cadmium, lead, platinum, and thallium.

Mercury Poisoning Case #1 Fecal Metal Results			
Metal	*Post-PCA-Rx*	*Pre-PCA-Rx*	*% Increase*
Mercury	.239 mg/kg	.009 mg/kg	2,655
Arsenic	<dl	.42 mg/kg	4,200
Cadmium	100 mg/kg	5 mg/kg	2,000
Thallium	.026 mg/kg	.003 mg/kg	860

Mercury Poisoning Case #2

A 58-year-old female was known to be mercury toxic from a DMPS challenge in June 2000. Her amalgam fillings had been removed only 2 months earlier. Her levels were in the "very elevated" range. In July, pre-challenge urine and stool samples were collected.

The patient then took three doses of PCA-Rx the first day, and another urine sample was collected the following morning. The patient was then placed on one dose per day for the following 4 days. On the fifth day, another urine and stool sample was taken. PCA-Rx increased lead excretion in the stool by almost fivefold and mercury

excretion, also in the stool, by twofold. Urinary excretion increased for lead, arsenic, tin, and thallium.

Mercury Poisoning Case #3

A 49-year-old female with mercury dental amalgams that were removed in 1997 had previously been on a detoxification protocol utilizing DMPS, chlorella, cilantro, and other chelators. However, by June 1999, her mercury levels were still very high and measured about 60 parts per billion in her urine with a normal reference range being only up to about 3 parts per billion. She eventually stopped her detoxification program because, according to the patient, she felt "bad all the time."

Symptomatology included low oral basal temperature between 97.2° F to 97.6° F, an increase in weight over the past 3 to 4 years, mildly enlarged soft thyroid gland, swelling in the feet and ankle areas, and abdominal pain. In addition, her menstrual cycles were recently shortened to anywhere from 21 to 24 days.

She was put on a detoxification protocol of three doses (consisting of 15 sprays per dose) for the first day and 15 sprays per day for the following four days. On the final day, stool and urine samples were taken and analyzed by Doctor's Data and Great Smokies Diagnostics Laboratory. Her mercury levels increased by 700% in the urine, and arsenic levels increased by 230%. Mercury levels in her stool increased by 330%, arsenic levels increased by 170%, beryllium excretion levels increased by 250%, and uranium excretion levels increased by 450%.

It is noteworthy that throughout the detoxification period, the patient reported no complaints or discomfort, whereas she had stopped her previous protocol due to "feeling bad all the time." This indicates that not only can PCA-Rx effectively remove heavy metals from the system, it is able to do so gently without undue discomfort to the patient.

PCA-Rx is a breakthrough in mercury detoxification that can be used daily since it does not increase excretion of essential elements. If you live in an urban area, have dental mercury amalgam fillings, are exposed to toxic chemicals at your job, or have experienced pesticide and chemical exposures—these are all valid reasons to begin a detoxification program.

The delivery method for PCA-Rx is as a trans-mucosal oral spray mist. The dosage is one to eight sprays one or more times daily.

The product was not specifically designed for autism. In the late 1990s, Cole and his chemist were discussing the devolution of humanity and the high incidence of disease, and they came to the conclusion that the result of today's many modern health-related conditions is nature's adaptive response to an overly toxic environment. Therefore, PCA-Rx was developed to possibly help eliminate the toxic burden at the intracellular level.

So the question is, Can it really help children with autism? Well, that's a difficult question to answer. The product has been studied by individuals but no published study has been done on it.* However that would be expected. It's from a small company, not particularly well capitalized like a Merck certainly, and its ability to conduct studies is limited. The product is sold as a dietary supplement. The company does not claim its product is a cure for anything. Cole has been trying to explain that it simply aids already healthy functions in autistic children, building the immune system, and the body does the rest. Cole also stresses the importance of a clean, preservative/chemical-free, organic diet including a good probiotic formula, avoiding foods that are reactive to sensitive systems, and eliminating exposure to toxins in combination with detoxification to best support the immune system. Strong

*As of this printing, Maxam Labs has begun conducting clinical trials, expecting the results to be published later this year.

government regulations, fairly enacted by Congress and carried out by the FDA, give the health and nutrition industry plenty of latitude to discuss how their products help maintain health, but once somebody ventures into the area of disease and cures, they are making so-called drug claims. We've approached as many people as we can who've used the product—and they are saying it helps. That's not science. It's common sense. Sometimes common sense goes a lot further than science. We finally have proven that an apple a day keeps the doctor away, but does that mean nobody should have been eating apples for the last few thousand years (Eve notwithstanding)? In other words, you can't wait for science to render final verdicts. Sometimes wisdom is found in personal experience related to another person. In each of the cases that follow, people wanted to help others by relating their experience with PCA-Rx.

Autism is as "curable," as any toxin-caused condition. We have many children main-streamed and no longer classified within the spectrum. As the toxin or contaminant is removed from the body, the "cure" is actually the body's natural cell replication response within a "clean" environment. There are specific supplements that we have learned about that parents use for children who experience autism. These seem to help, perhaps by supporting already healthy functioning pathways of detoxification. Particularly, clathration seems to help. PCA-Rx from Maxam Labs is probably most discussed and one of the most widely used of these products. Comprised of clathrators derived from bacterial organisms, PCA-Rx has been helping autistic children for almost 10 years with apparently no side effects that we have heard of and plenty of heartening success stories.

These stories don't prove anything conclusively about the product, but in a world such as medicine's understanding of autism, where there is nothing wholly proven and much theory and speculation, PCA-Rx is finding strong support. In fact, PCA-Rx is

probably the most talked about supplement these days in the autism community. (We hope we have played a role in telling people about this product.)

5

PCA-Rx and
Autism Case Reports

*In this chapter, we present actual case reports
from the world of autism, first reported in*
The Doctors' Prescription for Healthy Living.

CASE #1

Take the case of 3¹/₂-year-old Nicky Rivers,* first detailed in *The Doctors' Prescription for Healthy Living*. When Nicky was born, he weighed in at almost 9¹/₂ pounds, an excellent birth weight; everything seemed normal.

Nicky developed into a beautiful chubby little baby and hit all the milestones that babies should, noted his mother. He loved to play with toys, animals, and his brother. He even talked! Life was full of new experiences for him and he enjoyed every moment.

Unfortunately, unknown to his parents, Nicky was given a series of vaccinations contaminated with heavy metals. At that point, Nicky began to regress. Whether the link to the heavy metals is causal or not, what we do know is that by age 2, Nicky had lost many of the skills that he had learned. He didn't like playing with other children, he lost the words he knew, and he started doing self-stimulatory activities such as spinning and flapping his arms—as if he were lost to the world.

* *Name changed to protect privacy.*

Nicky lost interest in pretty much everything around him. His mom and dad were very worried. His mom cried a lot—especially after Nicky was taken to a doctor who diagnosed him as being autistic. The doctor also told his parents that there were really no proven biomedical interventions, and finding a good educational program for children with this "irreversible" condition would be their best bet.

His mom didn't concur with the doctor when it came to giving up and accepting the irreversibility of her son's condition. They tried many different foods and dietary supplements. Nicky currently is consuming gluten- and casein-free foods, which is helping. But when Nicky was given DMSA to lower the heavy metal load of his body, he became sick and lethargic.

Then, his mother started giving him the clathration formula, PCA-Rx, utilizing small-molecular-weight peptides. We are told these are the same byproducts of metabolism that friendly bacterial organisms use to detoxify their environment in the human gut, so it makes intuitive, as well as scientific, sense. The peptides attract and dislodge heavy metal molecules from cell receptors, capturing them in a three-dimensional lattice structure so that they may be safely excreted from the body. As we investigated, we found many lab reports from its users do confirm the ability of PCA-Rx to lower toxic heavy metal loads in both children and adults. It's just amazing how much data is being produced on this formula by the users themselves.

Ever since PCA-Rx, Nicky's mother reported he is talking "much more," can "understand more language," and has even "learned how to ride a bike." He wrestles with his little brother, can sing songs by himself, and, most of all, likes to be around people, smiles a lot, and kisses others. According to the family, Nicky is "having fun" and feels much better.

Because some heavy metal-related nerve damage now appears to be reversible and, indeed, reparable, about one month ago his mother added a second supplement, NG-Rx, to his regimen. NG-Rx is

thought to aid nerve cell regeneration and stimulate production of neurotransmitting chemicals, thereby further enabling Nicky to pay attention for longer periods during a six-hour school day.

NG-Rx, a neurotropic dietary supplement, contains acetyl l-carnitine, phosphatidyl serine, dimethylamino ethanol (DMAE), l-tyrosine, and other neural peptides. The nutrient particle sizes in this spray are formulated in nanometers and in a natural colloid that the body recognizes as a nutrient. These colloidal nanometer particles are better absorbed and, thus, the dosage required for similar benefits may be less.

The formulas appear to be helping. In a note from school, one of the teachers noted, "Nicky had a fantastic day today. His compliance and verbal programs were excellent. He had no aggressive behaviors and minimal self-stimulating behaviors. We had so much fun! He was talking about everything, and once I let him get one kiss from me, he couldn't stop. What a cutie!"

His mom was excited when she read that note! She said, "It is so cool that PCA-Rx and NG-Rx along with ionic minerals can help my child's body to heal. I want to thank [Maxam Labs] for giving my son the hope and the opportunity to be the healthy kid that he should be!"

CASE #2

Aaron and Noah, both diagnosed with autism, began using medically administered DMSA for heavy metal removal in the summer of 2001. Aaron, the oldest at age 9, has high-functioning autism (Asperger's Syndrome). Noah, age 5, has severe autism, and, as a result, was nonverbal, had a total aversion to food, and had multiple sensory issues. Although the DMSA removed some heavy metals from their bodies, they also suffered several negative effects (including sleep problems, yeast problems, severe fatigue, and dark circles under the eyes) from the treatments.

Kathleen, the boys' mother, first learned of PCA-Rx in December 2001, and in January 2002, the boys began using PCA-Rx combined with ionic mineral supplements.

Since that time, both boys' autistic symptoms have improved dramatically. Five-year-old Noah is now much happier and affectionate,

Urine Test Results, Male Age 5
Results reported in micrograms per gram

Metal	8/01 DMSA Only	1/02 Post PCA-Rx	3/02 Post PCA-Rx	5/02 Post PCA-Rx
Aluminum	35.5 mcg/g	23.7 mcg/g	<1.70 mcg/g	131 mcg/g
Arsenic	51.9 mcg/g	67.8 mcg/g	64.4 mcg/g	33.5 mcg/g
Cadmium	<.100 mcg/g	<.400 mcg/g	<.300 mcg/g	1.70 mcg/g
Copper	35.1 mcg/g	33.0 mcg/g	26.3 mcg/g	47.4 mcg/g
Iron	19.9 mcg/g	53.6 mcg/g	36.2 mcg/g	12.0 mcg/g
Lead	<.600 mcg/g	<1.60 mcg/g	14.1 mcg/g	.800 mcg/g
Mercury	.300 mcg/g	<.300 mcg/g	<.200 mcg/g	<.100 mcg/g
Nickel	<.300 mcg/g	<.800 mcg/g	4.30 mcg/g	<.200 mcg/g

Urine Test Results, Male Age 9
Results reported in micrograms per gram

Metal	8/01 DMSA Only	1/02 Post PCA-Rx	3/02 Post PCA-Rx	5/02 Post PCA-Rx
Aluminum	25.0 mcg/g	17.3 mcg/g	<.600 mcg/g	66.8 mcg/g
Arsenic	43.1 mcg/g	44.9 mcg/g	22.8 mcg/g	27.3 mcg/g
Cadmium	<.100 mcg/g	3.50 mcg/g	.500 mcg/g	.200 mcg/g
Copper	1.80 mcg/g	6.70 mcg/g	9.20 mcg/g	16.2 mcg/g
Iron	12.6 mcg/g	22.2 mcg/g	11.0 mcg/g	7.70 mcg/g
Lead	<.600 mcg/g	3.60 mcg/g	.800 mcg/g	<.400 mcg/g
Mercury	.200 mcg/g	<.100 mcg/g	<.100 mcg/g	.200 mcg/g
Nickel	<.800 mcg/g	<.200 mcg/g	<.200 mcg/g	<.200 mcg/g

considerably calmer, able to utter sounds and even small words, and also expresses interest in food; his teachers are even commenting on his progress. Nine-year-old Aaron is now also significantly calmer, more focused, interested in subjects common to his age group, more talkative, and interacting better with others.

Urine tests administered before and after using the PCA-Rx and ionic minerals (dates ranging from August 2001 to May 2002) also revealed substantial increases in the amounts of a few metals such as aluminum and lead released from both boys (see chart opposite).

In May 2002, Noah's mother started using NG-Rx to address Noah and Aaron's autism. She reports wonderful results, noting Noah's success with toilet training. She is very encouraged by their improvements and has additionally begun supplementing their diets with the Autistic Formula 1 and 2.

She looks forward to the day when her boys will say, "I used to be autistic."

CASE #3

Corey Noah was 5½ years old. He was diagnosed with PDD and ADHD when he was 18 months old. He was a happy child and liked to be busy all the time. Focusing and paying attention was very hard. But when he started using PCA-Rx four sprays per day on September 20, 2002, he seemed to awaken.

At the time of our report he had been named student of the week for his great behavior and for working hard in school. According to his mother, he was able to play and focus during soccer practice and games, and even got three goals. His speech improved also and his confidence grew. He now tells his mom when she forgets his spray medicine. He used to drive his mom crazy just for her to sit and read him a book, but now he asks her to read him four books, and when she asks questions regarding the books, he can answer them. His parents also give him four sprays of NG-Rx at nighttime. His mother

says she is "so happy that this product is helping…with every aspect of [his] life mentally, physically and emotionally. We are a Christian family and…would not write about this product if it didn't help…. This medicine is an answered prayer."

CASE #4

Lynn G. writes in an e-mail about her son, Keith.* "His teacher, speech pathologist, and in-home therapist all have noticed dramatic changes. Keith stood at an easel and painted for 10 minutes without stopping; the teacher said it was his first time ever where he didn't wander off, or stop, or become unfocused. She wouldn't even let any-one intervene to have him switch from the color red to another color, so I have one big piece of red artwork on my wall now. He is even becoming a little more playful with other children in the classroom."

According to his mother, Keith is receiving four sprays of PCA-Rx and four of AF-X each morning. Meanwhile, his mercury levels went down from 0.25 to 0.13, she reports, adding, "Most of the other tox-ins are also showing a higher number being excreted." In answer to the e-mail, Martha Cooley, another fan of PCA-Rx, wrote the fol-lowing:

That's great, Lynn. I hope he can get it all out. Are you seeing any cognitive or health changes? How many sprays are you doing to get the mercury moving?

We have been resting from detox for a month, but I am eager to pull the PCA-Rx and AF-X out again for Alex. He just got too tired and wasn't sleeping well and had pimples on his lower body, and we felt we needed to build him up awhile. What's interesting is that he's still show-ing progress every day, so something got cleared out enough for him to get some mental traction.

—Mary

* *Name changed to protect privacy.*

Lynn wrote again in an e-mail:

Hello, Everyone:

As I said, we have been awaiting the results of our hair test and after a brief run-through, Keith's mercury level went from <0.25 to a 0.13, which means he is now excreting mercury.

Most of the other toxins are also showing a higher number being excreted.

—Lynn

CASE #5

Linda W. tells of the dramatic changes in her son when she added PCA-Rx to his diet. When our son was a baby he was bright, happy, and hit all of his developmental milestones very early.

When he was about 2 years old everything changed. He stopped talking and started pointing and grunting. He wouldn't look at people and could not tolerate any noise. He became tense, frustrated, and angry. We sought help in both the allopathic and alternative medicine arenas. Our physician offered little help and even less hope. We tried auditory integration therapy, sound therapy, behavior modification, and dietary adjustments. Everything helped to some degree, but it wasn't until the addition of PCA-Rx that we began to see dramatic and sustained changes in our son. Testing by the school psychologist showed an increase in IQ of 30 points! The teachers in both learning support and regular education began noting remarkable improvements. As parents, we have seen so many positive changes. Our son looks at and talks to people, and they can understand him. He walks with a natural rhythm and stands up straight. He sings spontaneously and joyfully. He is starting to try new foods. He is happy. The dimple that disappeared from his left cheek 10 years ago is back.

We know that there is still a lot of work to be done with our son, but you can be sure that PCA-Rx will remain a part of his program.

These past 4 years have given us great hope for our son's future; autism is not so scary now.

CASE #6

The following is an e-mail letter from another family that found PCA-Rx extremely helpful.

Our son Fraser was diagnosed with autism in May of 2000; he is now 7 years old (we have twins, Fraser's sister Hallee is completely normal).

About 16 months ago we started to use the clathration formula PCA-Rx. We also completed very expensive, ultra-sophisticated, and extremely accurate urine and blood tests to determine whether or not heavy metals were being removed. The results were amazing. This formula really works. But the best news is that Fraser has shown truly remarkable improvement in both speech development and behavioral adjustment. After the initial success with clathration, we then added the AF-X formula, giving Fraser six sprays of PCA-Rx at night and six sprays of AF-X each morning. The resulting changes have been truly phenomenal. Fraser attends regular school with a full-time teaching assistant; everyone at school has noticed a major difference, particularly in his behavior. We know how well these products work because the few times that we have run out and not sprayed for several days, Fraser reverted to his former behaviors of knocking over racks of school books, running in the halls, and displaying extreme sensitivity to sound. After two days of spraying, he again returns to a calm and more focused state. I'm a professional filmmaker and presently working on a National Film Board of Canada production about Fraser. I have fully documented these amazing changes in Fraser, and they will be part of the production. It is my personal belief that Fraser was probably "poisoned" by mercury present in thimerosol, a preservative used in the measles, mumps, and rubella inoculations. Certain physiological conditions exist in some children, which make them particularly susceptible to the

effects of mercury. For some reason Hallee's physiology did not react to mercury in the same way as Fraser's.

PCA-Rx has probably removed all of the mercury in Fraser's body by now; (we have been using it in cycles for almost 15 months). We now are relying on AF-X and any of the other miraculous formulas that are being developed by Maxam to help him to fully heal his body and brain tissues damaged by the effects of heavy metal poisoning.

One of the other incredible effects of using PCA-Rx is that up until we started to use it, Fraser couldn't form any solid stools. (A prime indicator of "leaky gut syndrome" present in most autistic children, which was probably caused by mercury poisoning). He has now had fully formed solid stools for several months which indicates to me that mercury and other heavy metals which may have been resident in his intestines and colon have been removed and his body is now able to function properly in this area. He can now eat many foods that caused adverse reaction in him before. But even more significant is the fact that he is now fully toilet trained and doesn't even need a diaper at night.

I sincerely believe that PCA-Rx and AF-X have been the miracle products that are helping to bring our son back. I'm so glad that I found out about your products via the Internet. I'm passing the information on to other parents that I know with autistic children. I also know that my film will be seen by thousands of parents with autistic children. I hope that they try your products and have the same amazing results that we have had. Thank you so very much.

—Sincerely, Robert Fresco, Vancouver, British Columbia, Canada

CASE #7

The following is an e-mail letter from someone who found PCA-Rx to be better than other protocols for autism:

Dear Jim,

First off, thank you very much for your fantastic product line. I have a 4 1/2-year-old autistic boy. We had been using the DAN! Protocol to

chelate Miller's heavy metals—and it was a huge drag. He went non-verbal and non–toilet trained every weekend that we were chelating.

I began using your product in late March 2003. We have been extremely pleased and have found PCA-Rx to be a cost-effective chelation method that shows great results (his stool samples have shown your product behaving as you claim) with no regression—therefore, we are able to chelate/clathrate every day instead of 3 days out of 14.

I did not attend the DAN! [DAN! is the acronym for the group Defeat Autism Now!] conference this fall in Portland, but a mother from my autism support group did (by the way—I was disappointed that the doctors are at this point unwilling to try your product. I use DAN! doctor Stephen Smith from Richland, Washington. I have spoken to him often of your product and am pleased to say he now recommends it to patients).

Again, thank you for your products. As of July 15, our son is beginning to put out mercury in his stools. We have seen tremendous cognitive gains since then—slowly at first and then dramatically. He smiles! He laughs! He teases! Sometimes we feel that he seems downright neurotypical! This has been confirmed by my skeptical husband (chemical engineer and HARD SCIENCE MAN), my son's therapist, our daycare provider, Miller's school, my friends.

God's blessing to you. I look forward to hearing from you.
—*Tina Beeck, La Grande, Oregon*

CASE #8

In one case, a mother of two boys with autism spectrum disorder said of PCA-Rx: "It has been a blessing to us. We have twin boys and they are 3 years old. They both have been diagnosed with ASD."

At first, she gave PCA-Rx to her son, Nate, who was usually non-verbal and "hanging by himself and not seeing the world around him." Nate "would never look us in the eye or respond to his name. We have had Nate on the PCA-Rx for 30 days! What a difference in those days. Nate has come out of his shell."

She documented him on a daily basis since they started him:

On Day 4, we had eye contact! I picked him up from school and he really looked at me and gave me a hug. For the 1st time, I think he really knew who I was!

On Day 6, he started noticing people around him.

On Day 9, he actually touched a banana and ate it himself, brought me his shoes so he could go outside, and hit the ball off the T-ball stand!!!! I was in tears that day. Never did I think this day would happen.

Day 14, he played with some kids on the playground and said "Whee," when he went down the slide! My husband was so surprised that he never left the playground. He said that he wanted to be by the kids! =)

Day 21, Nate was mad at his sister because she brought him in the house. I asked him if he wanted to go back outside, and he answered me with, "Ya ya." I sat down with tears running down my face. I couldn't believe that he answered me.

Day 29, he is actually saying a few words. I am sure it is just the start! I am so excited watching him change!

He loves to take the PCA-Rx. He actually smiles now. I really believe that he knows that it's helping him.

His teachers do not know that he is on PCA-Rx. We wanted to see if they saw the changes firsthand, without knowing what we were doing. They both go to a special school for kids who have delays. Nate's teachers wrote this note to us yesterday. 'I have only been working with Nate for 5 weeks and he has made so many changes in that time. He is exploring so much more and willing to try new things. He has been making so much progress!'

Those are the best words that I have heard in a long time about Nate. He is finally seeing the world.

Thank you for making this great product. I can't wait to see the results when we start Alex on it!

We will keep you posted on our progress. I am so glad that we found you."
—*Sincerely, Roxie M.*

A later e-mail to Maxam Labs outlines further results as follows:
Hi,

I just have to update you on my boys.

Alex has been taking PCA-Rx, NG-Rx, and AF-X for 4½ weeks now. He has just blown us and his teachers away.

He only had a few words before and was not potty trained.

He couldn't sit still to listen to a story or do a project.

He is NOW potty trained and he is using 6-7 words in a sentence!! He was also moved to a preschool-like classroom at his school. He no longer needs one-on-one assistance. His teacher cannot believe the changes in him. I have been on Cloud 9 with all these wonderful changes with him.... I never thought I would see my boy like this!!!!

Nate is coming along also. He is using PCA-Rx, NG-Rx, and AF-X. He is more social and he is trying so hard to talk to us. He has a few words now and they seem to get better as each day goes by. He is also getting close to being fully potty trained too.

He got the best review ever from his OT and Speech teachers. I actually had goose bumps when they were telling me how amazed they have been over the past 6 weeks. He has shown so much improvement that they are totally amazed.

I have been handing out your business card to every parent that is interested in our therapy sessions, the school, and the teachers too.

I am so thankful for these wonderful products. I am really looking forward to more positive changes in the months to come.

Just looking into their eyes and knowing that they are really and truly looking back at you is hard to even put into words. Each day now has been like a whole new world for all of us. I can't tell you how many times a day my eyes get filled with tears when they say something new

or discover how to actually play with other kids or their sisters, or to even read a book and they point to a picture and tell me that the puppy or kitty has eyes, nose, and a mouth. =)

I truly believe in my heart that without your products, we would not be where we are today. I also know that with all the comments from other teachers and friends, I am not the only one seeing the boys' progress. =)

Please send me more of your business cards and any other information that you think would be great to pass on to help others. I have used up all of your cards already. I hope that these families will be calling or e-mailing you soon.

I can't thank you enough. You have really helped our family, and I enjoy telling others about your company and that they need to speak to you personally.

If there is anything that I could ever do, please let me know.

Thank you for listening to me, with all my questions, and making products that are giving me my boys back.

I will keep you posted on their progress.

Thanks again for the wonderful products; they have made our lives happy again. A lot less tears and a lot more smiles.
—Roxie M.

Results Still Positive For Alex & Nate—9/13/2006

Hi,

Just had to tell you that Alex and Nate had their psychological testing done yesterday.

Alex (WOW) used to be in the 20th percentile and after yesterday, he is in the 80th percentile. He is considered a "typical kid" with just a few quirks!!!!!!!! OMG!! Can you believe that? A typical kid!! I never thought that would ever be said to us about him.

I can't believe it! He is improving all the time. He is still taking PCA-Rx and AF-X.

He can count to 24 and write and spell his name. He can tell me that it is cloudy or sunny out. He tells me that his name is Alexander, not Alex! He can tell me that he is happy or sad and that he is missing one of his teachers who has left us.

Nate is improving, not quite as quickly as Alex, but that's ok. All I care about is that he has truly improved. Nate has always been 6-9 months behind Alex through all their developmental years.

Nate passed a lot of his tests, and he is still growing. He still has trouble verbally, but that has really come along too. That is the only area that he struggled with.

Nate is now eating chicken and lots of hot dogs. He is mimicking play and watching what other kids do. He knows when we leave the room, and he will run after us. He so loves to be around people now. He also lets us know when he doesn't want something. He will sit and let us read to him. He plays with toys now, the way a child should play with his toys.

So it was GREAT news for us!!!!

Thanks again for these great products. I do believe that we would not have had such a great day without these wonderful products to help my boys. I truly believe that. =)

This time we cried happy tears instead of sad!

Thanks again.

—Roxie M.

CASE #9

Diagnosed with PDD-NOS at age 3, Jake has experienced remarkable improvements after his parents discovered PCA-Rx at an autism seminar. Having used natural treatments including "allergy desensitizing, DAN! doctors, diet and nutrition, not to mention reflexology and other similar things to it," as well as heavy metal chelating, NDF, and a suppository to help excrete the heavy metals in his body, Jake's diagnosis was dropped from PDD-NOS to ADD by the time he was

5. His mother, who heads up statewide autism groups, noted significant improvements in Jake's abilities, watching him progress from a non-verbal child to entering school, but said he had a lot of trouble with writing and staying focused in school.

> *First grade was a nightmare for him—the longer day with the workload, and on top of it he cried every day before and after school. He even had thoughts about dying, and that scared me like nothing else had. I changed his diet and added more supplementation, and he seemed to improve in the second grade—at least he wasn't crying every day—but at times he got extremely frustrated with writing. By the end of second grade (just last May) his teachers suggested he use the keyboarding device to relieve his frustration at the beginning of third grade. They said they would give it a little time then put him on it. At the end of second grade, he had mostly C and D work with a lot of "needs to improve" on the report card.*

It was at that point she learned about Maxam Labs' sprays.

> *I started Jake on the PCM-RX (PCA with calming affects) and the NG-Rx at the end of June. And WOW! He is making such big strides in a short amount of time! Not only are the sprays effective, but so easy for him to take instead of the yucky oral stuff that is always a challenge to get him to swallow.*

Some of Jake's accomplishments since beginning the sprays included mastering swimming, while before he "would get started and just sink" now he can swim the length of the pool and compete and win races with his peers; better coordination and ability to dress himself, including putting his shoes on the right feet; increased motor skills, with a new ability to use a knife and fork; all accompanied by a more relaxed and happy mood. Encouraged by these improvements, Jake's mother added AF-RX, AV-RX, and Bioguard-RX to his regimen right before he started third grade. His success is overwhelming to her.

Starting third grade was a breeze, and he has brought home all As and Bs for the first time ever. Last year he had missed 4 days of school with four tardies in the first 9 weeks. This year we have only had one tardy so far, and that's because I overslept! He doesn't want to miss any school this year and says it's fun! He wakes up feeling more refreshed and doesn't complain about leg cramps. His stools look healthier, and we no longer need to use the occasional suppository. Ok, want to hear the best part? His handwriting is phenomenal and he has already mastered cursive—no more need for the keyboard! I asked him last week, "what is your favorite subject at school?" and do you know, he told me, "Writing is my favorite subject!!!!"

Your products were a godsend, and I will promote these to all of the parents I come into contact with...

Thank you Maxam Labs!!!!

—Sincerely, Julie Snoeberger

State Rep for Unlocking Autism in Ohio

CASE #10

Another parent of an 8-year-old who had experienced some positive changes from 3 years of chelation therapy expressed concern about the essential minerals and vitamins removed along with the heavy metals from her child's body.

"Occasionally, I would stop chelating for a period just to feel safe and give him a break."

When their doctor told them about PCA-Rx, the results were almost instant.

It had to be, at the most, 2 days later when the aide in my son's classroom asked me, "What have you done differently? Owen was so focused today!" His behavior continued on a great path. He is in 2nd grade and left alone to do his own work for the most part. He has accomplished so much! This really happened within a couple days of starting the PCA-Rx, and I am not one to believe these kinds of results when I

hear them. So for me, it was a very pleasant (and a bit surprising) experience. Well, thank you for now. I'll let you know again how things go with our next "round" of PCA-Rx.
—Sincerely, Margie L.

CASE #11

The noticeable results often evident shortly after using PCA-Rx also impressed the mother in this case study. With two daughters diagnosed as autistic, this mom noticed positive changes almost immediately when she gave PCA-Rx to her 32-month-old daughter.

I began with one spray in the early morning, upon waking. When they exhibited no negative reaction, I increased it to two sprays, then three, then finally four. My 32-month-old began responding to it right away. Her entire mood changed practically overnight; she became very happy and pleasant! This was a real change from the prior 6 months, when she seemed weepy and frustrated more often than not (which began right after she received her MMR and Varicella vaccination on the same day). Her ABA therapists noticed the difference too. They said that she is very cooperative and meeting many goals. They were very impressed by her performance! I have not yet told them about the PCA-Rx; I'm waiting for the right time. I've also since given her NG-Rx and AF-X, as well as bentonite clay baths. Her eye contact has noticeably improved too (though it's not perfect yet), and she's again saying some words that I haven't heard her say since the onset of her disorder last year, like "hat," "ball," and "apple."

She says while her 8-year-old is also exhibiting signs of progress, it's her 20-month-old son's reaction to PCA-Rx that truly amazes her.

As you can imagine, with two autistic sisters and the fact that he is a boy, I've been watching him very closely for any signs of autism, which I have come to know all too well. More boys are on the spectrum than girls, of course, and with two siblings on the spectrum he is practically a "shoe-in" for getting the disorder. His serum lead level at 10

months old was 9, which is "borderline," but that number didn't sit right with me. I suspect he may have the same problem his sisters have with excreting heavy metals from his body. Anyway, about 4 months ago, when he was 16 months old, I noticed his eye contact slipping and he began responding to his name less readily. A sense of horror and anguish came over me: Not again! Not a third child!

I immediately had him evaluated by Early Intervention and they noticed the same things, plus some other troubling behaviors like pulling up on a person to stand up as though the person were an object. I also started to notice him "spacing out" for a few seconds at a time, which I found very worrisome. I was devastated. But this time, I wasn't going to let autism take over without a fight. I started him on the PCA-Rx, four sprays a day during the afternoon or at night, exactly what his sisters were getting. When our chiropractor felt that the lymph nodes in his neck were swollen, I decided to order PC3X and give him that instead, because of the antibacterial and antiviral properties. I also ordered more NG-Rx and started giving him that—eight sprays in the morning. He also got clay baths.

Shortly after starting the PCA-Rx, his bowel movements became very foul. They were a greenish-black color—very unnatural—and smelled like toxic waste. There's no other way to describe it; it was a strong, unnatural chemical smell. I knew something was coming out of him but was horrified to think that that gunk was inside my sweet baby boy and to wonder how much more was in there and how long before it all came out! After a week or so his bowels became more normal. Well, after about 2 months on this regimen, I noticed his eye contact with me becoming more intense and lasting longer. As a result of his EI evaluation, he is now getting speech therapy, OT, and a special ed teacher coming to my home to do therapy with him, and they are all pleased with his progress—this only after about 3 months! He's acting more like a typical child, playing appropriately with toys, looking up when a helicopter goes overhead, looking at people who call his name. I really see

him coming back from what he was slipping into a few short months ago. Now that I've started him on liposomal glutathione and essential fatty acids, he's trying to say more words. And the "spacing out" episodes are gone; I haven't seen that happen for 4 months, now.

All I can say is, I'm amazed! I was really skeptical of this product, but it appears to work! And I'm not the only one noticing. Thank God! The results with my son are perhaps the most startling of all, since it seems (I hope I'm not speaking too soon!) that we may actually have averted something that was beginning to occur. Anyway, I am very impressed by these products and intend to keep using them with my children. Thank you so much for making them available!
—Sincerely, Rosemarie, New York, NY

CASE #12

An elementary school teacher tells of finding Maxam Labs' webpage and ordering PCA-Rx for her then 5-year-old autistic son, Antonio.

"Antonio has never been the same since," writes his mother.

At the time he started the treatment, Antonio had just turned 5 years old, was not potty trained, had few verbal skills and limited motor skills, and displayed a short attention span as well as autistic behaviors such as hand flapping, stemming, and tiptoe walking. After 3 weeks of taking PCA-Rx, he began to talk in complete sentences, sleep through the night, put together 100-piece puzzles, and learned to write his name—his hand flapping also reduced by 89%.

Antonio's mother then started him on NG-Rx. Within 2 weeks of starting this product, Antonio was potty trained and colored his first picture. His parents, doctors, and teachers were "amazed by his progress."

Encouraged, they started Antonio on the AF-X. That summer, he moved from a self-contained preschool to a typical preschool. He went from having speech, PT, OT, and some other therapies, to having none by August.

The progress just kept coming. My family and friends asked me what I was doing different, and I told them it was Maxam Labs' products. When my son was diagnosed with autism, it changed our lives forever; but with Maxam Labs, there is hope.

Antonio is now in first grade mainstream school, not self-contained, no special ed or resource, and no speech or OT. He is in a third-grade reading class and is on the principal's list, which is better than honor roll. He also enjoys karate, golf, and church. Antonio is doing so good that our local autism center came out to our home to do a story on him. They asked me what we were doing, and I told them about the gluten- and casein-free diet and Maxam Labs' products.

To look at Antonio before the PCA-Rx, NG-Rx, and the AF-X was devastating. To look at him now, you would not even know he has autism. I credit Maxam Labs' products for the progress in my son's education, mental status, physical and overall health—as do his doctors and teachers. His teacher this year believes in these products so much that when Antonio ran out of the NG-Rx, she gave me $100.00 to help get some more for him.

My favorite part is when his teacher writes me a note to let me know that she was gone yesterday and had a substitute teacher teach, and the substitute could not pick out the autistic kid. That right there is more than I could have hoped for. I could never thank Maxam Labs enough for the hopes, dreams, achievements, and goals that my son now has. Thank you from the inner depths of my soul for helping return my son to who he was meant to be.

—Sincerely, Jennifer R.

CASE #13

When this mom's 2½-year-old son was diagnosed with PDD, she began giving him natural supplements and contemplated chelation therapy but was wary of the side effects. Attracted to the safe and effective way PCA-Rx removes heavy metals from the body, she

started Danny on the product and saw a change in his mood "within days."

After a month, she decided to try NG-Rx in addition to PCA-Rx, based on recommendations of other parents. Some 9 hours after the first two sprays, she saw a "HUGE difference in him," citing an amazing leap in his social skills and interaction with other children.

I could not believe how social my son was. Pre-NG-Rx, he would be very aggressive with other children, have very limited interaction, and really kind of go off on his own more than seek to play with others. This time, though, he was running around with her children, laughing, taking turns going up and down the slide. What blew me away the most was all the children were sitting down having ice pops and my son has NEVER been interested in them, but this time, he wanted what the other children had. The little girl took him by the hand and asked him to sit down with her and gave him an ice pop and he did it!!! This was a HUGE step. I literally could not believe my eyes. It has now been just over 2 weeks since he started NG-Rx, and he is now on eight sprays a day.

Danny's mom expressed her elation with his language "explosion," calling him "practically normal and a happier child," and said that even Danny's ABA therapist is impressed by his progress. He wrote: "In 15 years of working in this field, I have NEVER seen a child progress this quickly."

That is when I knew this stuff is truly a godsend! I have no intention of EVER taking him off of this spray. Thank you so much, Maxam, for helping my little boy and for making him a much happier, normal child again!!
—Danny's mom

CASE #14

This family with three autistic boys, ages 2, 4, and 7 found themselves each taking some 35 nutritional supplements daily in an effort

to deal with autism, ADHD, and food allergies, including celiac disease and gluten intolerance.

Pointing to a possible connection between her children's conditions and the vaccine RhoGam, "which I now know to be loaded with thimerosal," and mercury in her breastmilk, Annie R. observed phenomenal changes in her boys' temperament and behavior after giving up the other supplements and starting on PCA-Rx.

"These products are the only ones that my boys don't have a reaction to," she said. "The changes in our family during this past year are nothing short of a miracle!"

Healthy weight gain, balanced muscle tone, stronger immune systems, and normalized bowel movements are some of the effects experienced by these boys. In addition, "Their autistic symptoms are virtually nonexistent," exclaims Annie, who said her oldest son's IQ is 130; her middle son is now talking, socializing, riding a bike, and reciting his phone number (as well as being potty trained!); and her youngest son, at 2½, is "like an electrical engineer," fascinated with electronics and appliances.

Thanking Maxam for bringing "normalcy" to their lives, she says the products they are using: BioGuard, Probiotics-Rx, AF-X, PC3x, PCA-Rx, and NG-Rx, with the later additions of AV-Rx, B-Max, Dia-Cal, PCM-Rx, and TRP; are a "precious gift!"

CASE #15

Saying she just wants to "shout out to the world to try these products," Emily M.'s 4-year-old boy, Alex, was diagnosed with high-functioning autism and had a poor diet and trouble interacting with other children.

"The only foods he would eat consisted of brown, crunchy processed foods, french fries, and pancakes," Emily explained.

Within a "couple of weeks" of trying PCA-Rx and AF-X, Alex's problems seemed alleviated, said his parents.

"To our amazement, he is eating grilled chicken, spinach, salmon, and many other foods. It is almost as if he woke up and is discovering food for the first time. He interacts with others and loves to play outdoors," they wrote.

Others are noticing the positive changes in Alex too.

"I didn't tell anybody that I was giving Alex these products, and everybody has been telling me how great he is doing, *including his teachers*," said his mother.

"These products *will* change your life and the lives of the people you love."

CASE #16

Brian and Bianca of Houston, Texas wrote to thank Maxam Labs and share their experience with the products. In less than a month and a half of taking PC3x and AF-X, their daughter, Juliann, began showing improvements in symptoms and continued to make progress throughout the months during which she followed a regimen which also included PCA-Rx and NG-Rx.

Prior to her treatment, Juliann exhibited the following behaviors:
- Lack of eye contact
- Lack of social engagement
- Lack of appropriate play
- Little to no verbal language
- Erratic sleeping patterns
- No writing ability outside of scribbling
- Frequent outbursts during school
- Violence toward others, especially teachers
- Poor eating habits (crunchy, brown carbohydrates, candy)
- Opposed to change in routine/environment
- Sensitivity to certain noises/music

Her eye contact was the first thing to improve; next came following verbal commands. Her teachers reported improvements in her

attention and behavior on a weekly basis, and her sleeping patterns and language consistently improved as well.

When she wrote her name about 6 months after starting her Rx treatment, Juliann thrilled her great-grandmother, along with her parents and teachers.

"Imagine our surprise to see her do this! It was as if someone had flipped the light switch on," her parents wrote.

Today, at 7 years old, Julian speaks in short phrases, role-plays with stuffed animals and dolls, writes her name, follows verbal commands, dresses herself, sings her ABCs, and transitions easier.

Justifying what some of their family members consider a high cost for the treatment, Juliann's parents explained, "No price is too high to rescue our little girl from the dungeon of heavy metal toxicity many call autism. Speaking as a parent to other parents out there who question whether or not these products are worth the cost, I will always answer with a sound and confident "yes."

Update

Brian and Bianca also treated their son, Adam, with PC3x and AF-X, following the same regimen that they did with his sister, Juliann, of two regimens of PC3x and AF-X, followed by two regimens of PCA-Rx and NG-Rx, administered for 6 months.

Previous to the treatment, Adam exhibited the following symptoms:

- Lack of eye contact
- Lack of social engagement
- Lack of appropriate play
- No verbal language
- Constant climbing (on the outside rails of staircases, for instance)
- Violence toward others (especially himself)
- Poor eating habits (crunchy, brown carbohydrates, candy)
- Opposed to change in routine/environment

• Sensitivity to different people's voices

"Probably the most devastating event was when Adam lost his speech," wrote Bianca. By 17 months old, he had stopped talking, having formerly said, "ma-ma," and "grandma."

Less than 2 months from beginning the Maxam products, Adam began to make noises again. In addition, his eye contact began to improve, and his early childhood intervention instructor said his new-found attention span "…gave me chills." Nearly a year later, Adam began to verbally add the names of the letters to his signing of the alphabet. Soon after, he began counting from 1 to 10, and today, at 4 years old, Adam has continued to improve.

"His recent accomplishments include eating oranges, coloring (still a scribble but a huge improvement from a year ago), and playing games with his older brother, Aaron," said his mom, who believes Juliann and Adam were "reborn" developmentally when they began taking the Maxam products.

CASE #17

Mary M. wrote to thank Maxam Labs for "bringing her daughter back," as she tells the story of her daughter's autism, perhaps brought on by a childhood vaccination.

Dear Maxam Labs,

Our daughter was born on May 7, 2001. She had a complicated birth where she was born unresponsive and not breathing. A neonatal specialist revived her and incubated her, and she was admitted to the Neonatal Intensive Care Unit for 7 days. On Day 7, we were ecstatic to bring home our daughter who was delightful, loving, and so aware of her world.

Everything went well until we took her to her 8th-month checkup. I had been spacing out her vaccinations as a personal choice from research I had done on the subject. At that 8th month visit, she received three vaccinations. Even though I was extremely reluctant (it's called

Mother's intuition), I was assured by her former pediatrician that it was safe, and that I would be negligent if I didn't catch her up on her program. For 24 hours thereafter, she experienced a low-grade fever and she cried inconsolably all night. We noticed that she stopped babbling and imitating speech sounds. She began rocking on all fours on the floor and banging her head in her high chair. We were extremely concerned, so we had her evaluated and she was diagnosed with autism.

Her new pediatrician, Dr. Mary Megson, specializes in the treatment of autistic children. She started her on a supplementation program and cod liver oil. My mom, Grace Macauley, an N.D. in Fredericksburg, Virginia, had already started her on a gluten-, casein-, and peanut-free diet. We also bought organic meats, eggs and produce for everyone in our household to eat. We noticed some improvement, but we still had a long way to go in her recovery. My mom discovered and started her on a natural chelation product that was made from chlorella and cilantro to chelate heavy metals from her system. She was on that product as well as a foot cream for well over a year, with mediocre results. It was one defining moment when we saw your advertisement for PCA-Rx that turned our world around. Shannon started on the PC3x for 2 months and then on the PCA-Rx for 1 month. We sent in a urine sample for testing and the results came back that she was excreting two-and-a-half times the normal level of mercury!! Not one of the other products she had taken was even touching the mercury!! We were absolutely amazed as was our pediatrician!!

Shannon started to really make changes. Her vocabulary was increasing daily by leaps and bounds. One afternoon she looked me right in the eyes and told me that she was happy and that she loved me, for the very first time!! At her latest appointment with Dr. Megson, the diagnosis was lifted and she can no longer be labeled as autistic!! We are proud to share that she will soon be going to regular preschool!! If it weren't for us seeing that one advertisement of yours, we might have

never known of your products!! Boy, are we glad that we did!! Your products are a MIRACLE and I am sharing that with everyone that I meet!! There is no limit to my happiness and willingness to share your product information. Thank you from the bottom of my heart for helping our family "get our daughter back!!"
—Mary M.

CASE #18

A. L. in Washington first ordered PCA-Rx and PC3x to help remove heavy metals from her body. Having read about the link between autism and heavy metals, she decided to try the PCA-Rx on her 2-year-old daughter, Miriam, who is believed to be autistic.

"At 2¹/₂, Miriam is very unresponsive and has about a one-word vocabulary and usually points to what she wants and takes very long naps of 4 to 6 hours," she said. After giving Miriam her first two sprays, A. L. was astonished that she "noticed a difference the SAME DAY!"

Miriam was much happier the next day and was attempting new words. I have been giving her two sprays a day for 3 weeks now. She is MUCH more verbal, saying many more words, trying to sing, more outgoing, and sleeps a lot less. Naps are now 2 to 3 hours, and best of all, she no longer points. I am really amazed at all of her progress in just 3 weeks.

CASE #19

Michelle P. wrote to tell about the positive results her entire family has experienced from using Maxam's products. Dealing with conditions ranging from autism to juvenile rheumatoid arthritis, each of the family members has noted amazing improvements in their symptoms through the use of Maxam Labs' products.

"My 6-year-old autistic daughter is taking PCA-Rx, Bioguard, Probiotics-Rx, and AF-X. We saw notable progress, but it wasn't until

she began the AF-X that the WOW! factor came out," wrote Michelle, who said she now gets almost daily amazing reports from school, where her daughter has gone from saying a handful of words when asked to do so, to talking spontaneously.

"Clarity came with existing words. She has verbally expressed and vocalized her wants and so many new words, that I've lost track counting. She has been able to put up to two to four words together at a time. She is raising her hand asking to lead the group in calendar/circle time. She is doing more age-appropriate things. Her acquisition of skills is growing quickly. There are just so many things, I could go on," her mother wrote.

She also mentions a big change in her daughter's temperament.

"Her OCD, temper tantrums, meltdowns, aggression, and more have significantly been reduced."

She also told of her 5-year-old son with JRA (juvenile rheumatoid arthritis) who is obtaining relief from the arthritis pain he previously experienced.

"He is on Cellaflex, PCA-Rx, Probiotics-Rx, Bioguard, and AF-X. Since being on these products, he has lost a lot of his arthritis pain and can function normally. We have had a few times when he didn't get the Cellaflex and the pain came back."

Noting his improved behavior, Michelle also mentioned her own success with Maxam, saying the products she's taking have helped with her "brain fog, chronic sinus infections," and constant exhaustion.

"Since I've been on Maxam's products, I have more energy and have been healthier, and I have clearer thinking."

Michelle also said she and her family experienced some side effects from the products, such as constipation if they didn't drink enough water to flush out their systems. They also experienced some sore throats and flu-like symptoms, but "that's about it. I have found Maxam to be amazingly supportive," wrote Michelle.

"The products are expensive, but for us, they have been well worth it," she added, telling how a friend's family have also been experiencing "wonderful things" with Maxam's products.

"All of our children are as different as different can be, but the bottom line is, we *ALL* saw significant progress. Can I explain the science behind it? Not really. I, too, am just a mom trying to help my children and want to share our experience with the hopes that it can help someone else. There is something valuable in these products."

CASE #20

J. K. Lamb and his wife were devastated and in denial when their pediatrician suggested their son, Samuel, might be autistic.

"His pediatrician was the first to notice it. Samuel wouldn't look at her and seemed to just stare off into space," wrote J. K. "We kept trying to prove to ourselves that what she said was wrong."

Watching Samuel withdraw from the world and "just sit in a corner and stare at a book or a toy that had lights, music, or water," Samuel's parents realized the diagnosis was correct.

"People commented that he wouldn't interact with their children when he was around them," he said. "We wanted so much to hear Samuel speak and to connect with our family, yet he was so distant; he was not 'with' us. It brought us to tears."

Doing their research, Samuel's parents implemented the gluten-free, casein-free diet for Samuel and noticed some improvement in eye contact.

They learned of chelation therapy to remove the heavy metals and mercury toxicity (possibly due to vaccinations) that was probably causing many of these autistic symptoms. Reluctant to subject Samuel to what they felt was a harsh chemical treatment, they struggled with the need to detoxify their child, "but we couldn't bring ourselves to put him through all that."

"It seemed like chelation therapy was a chemical treatment that was

very exhausting and harsh on a child's body. We read stories of children getting physically sick and being very tired and strung out on the days these chemicals were administered."

Samuel's parents credit God with leading them to Maxam Labs' PCA-Rx product "as a safe way to eliminate toxins from our son."

They noticed a "huge difference" in Samuel, and in 6 months "he is definitely 'with' us now!" said his dad.

"He now smiles at us often and interacts with us on a whole different level than before treatment with PCA-Rx. He is learning the motions to songs at his special education school and he has begun to imitate play actions. We also hear him making new sounds that we have been told by professionals are the beginning of speech development," wrote J. K.

His parents say they are confident in Samuel's recovery.

"We have tremendous hope for Samuel's full recovery from the evil of autism. We are also administering AF-X and NG-Rx to him and know that it's these products that are making a huge difference in our lives."

CASE #21
Beamer's Progress—11/23/2004

Dear Maxam,

It has now been just over 2 months since Beamer started taking AF-X and PCA-Rx. I have to say when the spray first arrived, and I read I had to spray it under his tongue and have him hold it in his mouth for 2 minutes, I almost cried. To be so close to something that I believed might help him, and not be able to give it to him, was beyond belief. I quickly called your 1-800 number and pleaded for help. How was I going to get an autistic child who was not even 2 yet to cooperate with this method of administration? I was very relieved to be assured that this was not a worry. As long as I could get the spray in his mouth, that was all I had to do.

Everything I believed would happen has happened. Beamer is a completely different little boy. Before the spray, he had no words at all. I had taught him sign language to try and ease his frustration. This was working well, but speech was our goal. He no longer grits his teeth and grunts. He actually talks, and I mean understandable words.

He is not just mirroring our actions, he knows what the words mean and uses them appropriately. After about 2 weeks of using the spray, the words started. I awoke one morning hearing him call "Mama" over his monitor. It took me a few seconds to realize that it was Beamer calling me. How my heart soared—he knew who I was and he called me. I had a name. From this point on, more and more words followed. I had been using Baby Bumblebee videos with him, and now he lets us know that he has learned everything on them. He knows his whole alphabet and can say each letter. He knows his colors, and he knows his numbers to 12. Speech was our big goal, but we have seen so many improvements since starting with the AF-X and PCA-Rx.

He plays pretend now. We love to watch him playing with his little plastic Pooh, Tigger and the whole gang, and giving Pooh rides on Eyeore's back. He plays with all his little farm animals and makes all the sounds they make. Now when he watches his videos, you see the understanding in his smiles and he laughs—at the appropriate times, I might add. He no longer only eats round, brown foods. He is willing to try more different foods. He even tried celery. Every day he says many new words. This morning he was playing with his Pooh figurines, and asked for Pooh's house. It came so easy to him; he just looked up and said, "House, please." He was playing with Playdough this morning, and he and Papa made some balls. He dropped one and couldn't find it; he kept looking and then shouted, "There it is," as plain as could be. He takes directions now. You can tell him to look behind, and he does. If you say it is under the chair, he will look for it. If you ask him to get something from another room, he runs off and gets what you have

*asked for. The other day after watching "Beauty and the Beast," he ini-
tiated a game of the Beast chasing him. He ran through the house with
his little Hot Wheels suitcase of cars, dragging behind him yelling,
"Beast, beast," and laughing. He comes for hugs, for no reason at all.
He will be playing and walk over and give us a hug around the legs,
just to let us know he cares. I could go on and on, about the changes,
but I think I have told you enough to get the message across that he is
doing wonderful. The other night when I tucked him into bed, as I was
leaving I said, Love you," as I always do, only this time he responded
with a "Love you." I think that says it all. He knows who we are, he
knows who he is, he feels emotions—not just anger and frustration, but
happiness and love. To anyone that has doubts if these products work,
I say try them, you have nothing to lose and a whole new world for your
child to gain. I don't know how long he will have to keep using these
sprays, but it really doesn't matter. Time is on our side now. We are
winning. By the way, Beamer is 2 now, and I don't think you could
pick him out in a group of children as the one who has a problem.
Thanks for all your help.
—Heather W.*

Wonderful Update to Beamer's Progress—2/15/2005

*I just wanted to give you an update on Beamers' progress. He con-
tinues to take his AF-X and his PCA-Rx, and he keeps progressing in
leaps and bounds. We had testing done on him by a speech therapist,
and the test results were amazing. He is now in the 94th percentile
group. Translated, that means that only 6% of children his age have a
larger vocabulary; 50% is the average range. So his vocabulary is larger
by 46% than most normal children. Not bad, considering he was com-
pletely non-verbal in September; that is only 4½ short months ago,
unbelievable. That is his spoken level; his comprehension level is much
higher. He is putting two and three words together at a time. Not only
can we understand him, but so can perfect strangers. Sometimes this*

leads to a few embarrassing moments, such as when he saw a man in the store with a white beard and he insisted it was Santa. Strangers often comment on just how chatty he is; we just smile and say, "yes, he is, and we love it." His speech therapist (who he only saw three times) feels there is nothing she can offer him because he is progressing at such a rapid rate. We have seen great improvements in other areas also. I can't remember when he had his last temper tantrum.

We have just returned from a long trip to Florida. It was his first time since he was 6 months old in an airport and through security (which can be trying to the best of us) and a long flight. We were prepared for some transition problems but were very surprised when there were none. We encountered no problems in going from one hotel to another; he settled in with no adjustment problems at all. We had been very apprehensive about this trip, and were just blown away at how easy it was. It was like traveling with a seasoned traveler. He has come a long way from that little boy that it sometimes took us upwards of a half hour to get out of his room. Since we have been home, we have looked at videos taken of him last summer. I don't think we realized how silent he was. It is quite heart wrenching to watch those videos and know that without the AF-X and the PCA-Rx, he would still be that silent lost little boy.

It is with great joy that we move on to the recent videos and listen to him chatter and watch him play and run from one animal to the next at Disney's petting zoo, saying, "Gentle, gentle," as he pets the animals. He loves to watch himself on the videos, and comes and asks for Beamer, and then tells you which he wants to see. We have many for him to pick from, all filled with his laughter and chatty little voice. The only sad note to all this progress is that we wish that there was some way of getting this information out to more people. It is upsetting to think that there are so many children out there suffering needlessly, because their parents don't know about these wonderful products. We will continue to tell everyone we meet about them because we know

without them where Beamer would be: sitting silent, emotionless, and sad. How we celebrate every noisy, fun-filled day we have with him now. Thank you again!
—Heather W.

Beamer's 3rd Report—7/7/2006

Hello,

Nice to hear from you. How is Beamer doing??? Where do I begin? He is just the most amazing 3-year-old little boy. He is very high on life and sings and plays all day. He is never quiet; he has a great deal to say. We are always happy to contribute in any way we can, to help get the information out there, to let others know that there is help, and that your products really work. I am attaching a couple pictures of Beamer. They show him as he is: a happy, content, normal little boy. He has been going to a junior kindergarten program at a university preparatory private school since last February. He has done amazingly well. I will share the remarks from his report card with you. "Beamer shows such obvious curiosity and competence in so many areas of development that I felt compelled to assess his development from ages 3 to 6 years of age. He is a pleasure to have in class. Beamer displays cognitive ability well above normal expectations. His social/emotional development is also noteworthy. Every day spent with Beamer reinforces how privileged I feel to be a part of this formative time in his life. I look forward to spending another year with Beamer and guiding his learning."

This is a story his teacher shared with me on this report card. She entitled it, "A Precious Moment": "I sat on the lawn watching the children at play. Beamer stood next to me. His body stood straight. His head was level with mine. 'Miss Vicki, will you be my queen?' he asked.

'Of course,' I replied. 'But couldn't I be the princess?'

'No' was the answer. 'E— is the princess. I want you to be my queen. I am a knight. A very nice knight, and this is my sword.' He made a fencing motion with an iris leaf. 'I will protect you, Miss Vicki.'"

His head mistress added this comment: "This lovely story is surely indicative of the creative and compassionate character of Beamer."

Thanks to his PCA-Rx and AF-X, he is developing to his full potential. Without everyone at Maxam Labs, this story could never have happened. We will be forever grateful, as will he, when he is older and fully understands. Every day is a new experience with him. Right now, his big love is the "Cars" movie. We have been to see the movie twice, and he is collecting every car. The other day he bought a Cars watch. He was on his way to his sandbox, and he looked down and said, "My watch will get dirty. We better take it off." He amazes me with the way he thinks ahead and realizes the consequences of his actions. He also bought the Cars sunglasses, and they are magic. When he wears them, he is able to tolerate loud noises that would normally bother him. His imagination is unbelievable. We are all named different cars these days. He, of course, is Lightning McQueen, faster than fast, quicker than quick. He is Lightning, and he has all the lines memorized. I am Sally, his girlfriend, and Papa is Tow Mater, his best friend. He watches the movie trailers on his computer, which of course he operates completely on his own. He can do things on the computer that I don't know how to do.

My husband and I are going to start taking NG-Rx to try and keep up mentally with Beamer. He is already very quick to correct us when we make a mistake in naming dinosaurs, or in re-telling a story not quite the way he knows it should be. It is quite scary to be corrected by a 3 year old, especially when he is right!! It is also wonderful to know that he is so quick and so bright. Thanks again for all your help with Beamer and now with Ethan. We are looking forward to getting him started.

—Heather W.

6

Frequently
Asked Questions

These questions and answers are from Maxam Labs.

Q: *What does PCA-Rx do?*

A: PCA-Rx naturally and gently removes heavy metals, toxins, and various substances that are NOT naturally supposed to be a part of the blood, lymphatic fluid, or cerebral spinal fluid. PCA-Rx becomes a natural part of our immune system by up-regulating genetic expression and immune functionality.

Q: *Will PCA-Rx in any way cause liver congestion?*

A: In over 10 years of use, there have been no indications that PCA-Rx will cause liver congestion.

The action of PCA-Rx actually encourages and promotes healthy liver function and has been used very effectively by persons suffering from various liver ailments.

Q: *If PCA-Rx helps liver function, how does it remove toxins from the body?*

A: Laboratory tests have shown toxin removal to be approximately 85% through the stool, 10% through the urine, and 5% through the skin and breath.

Q: *Will PCA-Rx cause any constipation?*

A: Depending on your personal toxic accumulation, we recommend starting out with a very low dose, i.e., 1 or 2 sprays for the first day or two, and gradually work up to a higher dose, i.e., 4 to 8 sprays per day. You've been collecting toxins your entire life, be patient. It is also recommended to drink at least one-half ounce of water per pound of body weight each day to help with toxic elimination.

Q: *How soon will I notice results from PCA-Rx?*

A: In some cases, for people that had previously removed all environmental contaminates from their life, the results were profound, life changing, and took 3 or 4 days. For others it's a more gradual cleansing process. Most people notice an increase in clarity and thought process in the first couple of weeks. By the third and fourth week, some report they feel much lighter, clearer, and their friends remark how good they look. This is all relative to age, previous toxic exposure, diet, ongoing environmental contamination, and the level of bodily degeneration. Results may vary.

Q: *How long should a bottle of PCA-Rx last?*

A: Each 30 ml bottle contains approximately 240 sprays. At 4 sprays a day, that's a 60-day supply. Some sensitive people have reported excellent results at 2 sprays a day, making a bottle last for 4 months. The body only has so many pathways for toxic elimination. Less is usually better.

Q: *Is PCA-Rx safe for children?*

A: See the autism reports under "Featured Articles" from the home page. In over 10 years of use by thousands of parents, there have no reported negative indications in children. PCA-Rx has been used very effectively on children of all ages, from 1 month up. Several cases have been reported to us that involved lead poisoning of very young children, with dramatic results at 2 sprays a day over a 3-month period. PCA-Rx has also been used immediately after vaccine inoculations to counter the toxic effects of mercury and other contaminates.

Q: *Why is PCA-Rx so expensive?*

A: PCA-Rx is not your average herbal detox product. It is the result of over 18 years of extensive research into how the body and the immune system function. PCA-Rx is a complex structure unto itself and very much a part of our own human process. Our cost to manufacture and maintain the life force and intelligence of PCA-Rx is actually astronomical. All of the minimum profits are returned back to research.

Q: *How does PCA-Rx compare to other forms of chelation therapy?*

A: PCA-Rx becomes a natural part of our immune system. It is as natural to us as living food, and it has a very discriminate, synergistic cleansing effect on the body. Other types of chelation are basically drugs, chemicals, or dead herbal products, and although marginally effective, they create an indiscriminate stripping action in the body (they remove the toxins based on their affinity list, e.g., mercury for a week or 2, then lead for 2 weeks, etc.), potentially causing an imbalance if proper mineral supplementation is not provided. The use of drugs, chemicals, dead food products, additives, toxins, environmental contaminates, and the like have gotten us into our various states of ill health and are mainly the causes of chronic, debilitating diseases. Chemotherapy can be very effective, but it does have its side effects.

Q: *Will I experience any detox reactions?*

A: Most people wouldn't. Some very sensitive people have reported a slight tiredness when they first start taking PCA-Rx. If that is the case, take the product every other day at a low dose and gradually increase as the immune system becomes stronger. Remember, less is usually better in the beginning.

Q: *Are there any side effects?*

A: In over 10 years of use, there have been no indications of negative side effects. The human brain and body function on electrical signals. Heavy metals and toxins create resistance to the flow of this intracellular communication process. As the resistance, or toxin, is removed, there will be increased neural function and electrical activ-

ity. This is normal. With children, try to keep them focused and in a learning environment as new neurons are being formed.

Q: *Does PCA-Rx cross the blood-brain barrier?*

A: Many of the veins and capillaries in the brain are as fine as hairs, necessary for the transport of oxygen, blood, and nutrients. Over time these pathways of life, thought, and memories become clogged with plaque, toxic residues, metal deposits, etc.

Some older users of PCA-Rx have remarked on an improvement in thought process and recall ability, stating that for the first few days their brain was "tingling, like it was waking up and coming alive."

Q: *Do I need to have my amalgam fillings removed before starting the PCA-Rx?*

A: The accumulation of heavy metal poisoning, i.e., mercury, has been going on for your entire life. In most cases, if the fillings are tight and non-leaking, the immune system needs to be stabilized, with the cleaning of cellular mercury prior to the removal or disturbance of any existing fillings.

If you plan to replace your amalgam fillings, it is suggested to take 1 or 2 bottles of PCA-Rx before starting the amalgam removal. The amalgam removal may increase your toxic load. It is suggested to take the PCA-Rx while the amalgam removal is going on and take it for an additional 2 months after.

Q: *What is the strep bacteria in PCA-Rx? I thought strep was a harmful bacteria—please explain.*

A: *Streptococcus thermophilus*, besides being one of the starting bacteria for PCA-Rx, is also one of the primary bacteria in yogurt products. On the yogurt label it will just read *S. thermophilus*. The harmful bacterial form of strep is *Streptococcus aureus*.

Q: *My health counselor recommended your PCA-Rx to me for detoxification with my amalgams. My question to you is can I use this product while still having other fillings (silver/mercury fillings) in my mouth? I plan to do the mercury filling removal a little at a time, since last year I*

had a quadrant removed and I was barely able to walk for 8 months afterwards. This product also clears away mycoplasma? Is the mycoplasma somehow stuck to the mercury inside the body?

A: We would recommend that you should start taking the PCA-Rx a few weeks before you begin the dental procedure, and continue taking it throughout the process. I don't think you will experience the trauma you had last time.

Mycoplasma is a term that has been used to identify a group of microorganisms found living in the blood and cells of persons with certain chronic illnesses, such as Lyme disease, EBV, CFS, and many others.

Q: *I have a 4-year-old son who has been diagnosed autistic and who is currently undergoing a treatment with DMSA and lipoic acid for chelation. I have done some fairly extensive research on chelating agents and understand the drawbacks of using DMSA.*

A: DMSA and DMPS are believed to draw out valuable elements like calcium and zinc while also drawing out mercury.

7

Should PCA-Rx
Become Part of the DAN!
(Defeat Autism Now!)
Protocol?

In 1995, one of the leading researchers into the field of autism, Dr. Bernard Rimland, brought together a group of experts to brainstorm the nutritional, genetic, and chemical factors that might be involved in autism and other autism spectrum conditions. Their sessions, refined over the years, brought about what has been popularly called the DAN! (Defeat Autism Now!) Protocol. Briefly, the DAN! Protocol eliminates casein in dairy, gluten in certain cereal grain products, and, of course, all other junk foods, and includes an important nutritional supplement component.

Since autistic children have been shown to accumulate heavy metals, which are thought to be a primary cause of defective cognitive function, the DAN! Protocol includes either DMSA or DMPS as the primary detoxification methods for heavy metals. Unfortunately, although heavy metal removal is a very important part of the health and healing process, the side effects associated with DMSA and DMPS have become a real concern among parents of autistic children.

In fact, as early as February 1999, Cornell University researchers reported that DMSA might alter immune function, according to results of a study of pregnant rats and their offspring. Reporting in

the journal *Toxicology* (1999; 132(1): 67-79), the researchers say it is not known if the so-called chelation therapy has the same side effects in humans as was observed in pregnant rats. One cause for the immune system impairment could be DMSA's effect on the availability of essential minerals in the pregnant rats and fetuses. A candidate mineral could be zinc, which is crucial for both development and maintenance of the immune system.

Thus, families with autistic children have now begun to modify the DAN! Protocol by including a fermented probiotic oral spray formula called PCA-Rx as their chelation/clathration treatment of choice.

It is our opinion that although DMSA and DMPS have shown marginal effectiveness, too many parents are complaining about the side effects of these drugs.

Although the DAN! organization hasn't included PCA-Rx in its DAN! Protocol, we think it is time to seriously consider its inclusion. Many parents have asked the organization to do so. Meantime, *The Doctors' Prescription for Healthy Living* has reported month after month on the successful results autistic children are receiving with PCA-Rx—and without the side effects of DMSA or DMPS. Their heavy metal levels are being reduced, and their cognitive and behavioral skills are enhanced.

Despite the fact that PCA-Rx is not included in the DAN! protocol, many DAN! doctors are using it and finding success with their patients. In a written advisory which *The Doctors' Prescription for Healthy Living* has obtained, Joanne Sheehan, director of exhibits for Wellness Workshops at a DAN! Conference, noted, "The Consensus Committee has developed a protocol for dealing with removing mercury and other metals and it involves only DMPS and alpha-lipoic acid. While we recognize that there are other substances that have met with success, at this time the committee wants to adhere strictly to its protocol. Until the Consensus Committee revisits developments in chelation, DAN! is unable to accept exhibits for products that use a

different method." That was six years ago. Could it be that now is finally the time for clathration to be revisited?

References

1 Sandler, R.H., et al. "Short-term benefit from oral vancomycin treatment of regressive-onset autism." *J Child Neurol*, 2000;15(7):429-435.

2 Wakefield, A.J., et al. "Enterocolitis in children with developmental disorders." *Am J Gastroenterol*, 2000;95(9):2285-2295.

3 Pinesap, J. "A neurochemical theory of autism." *Trends in Neuroscience*, 1979;2:174-177.

4 Reichelt, K.L., et al. "Gluten, milk proteins and autism: dietary intervention effects on behaviour and peptide secretion." *Journal of Applied Nutrition*, 1990;42(1);1-11.

5 Reichelt, K.L., et al. "Childhood autism: a complex disorder." *Biol Psychiatry*, 1986;21:1279-1290.

6 Garvey, J. "Diet in autism and associated disorders." *J Fam Health Care*, 2002;12(2):34-38.

7 Quigley, E.M.M. & Hurley, D. "Autism and the gastrointestinal tract [editorial]." *Am J Gastroenterol*, 2000;95(9):2154-2156.

Resources

PCA-Rx is available from Maxam Labs. Their toll-free number is (800) 800-9119. Their website is www.maxamlabs.com.

Heavy Metal Testing Labs include Doctor's Data at www.doctorsdata.com, Great Smokies Diagnostic Labs at www.gsdl.com, and Great Plains Laboratory at www.greatplainslaboratory.com.

For further updates from *The Doctors' Prescription for Healthy Living* visit www.freedompressonline.com.

Index